GOYA

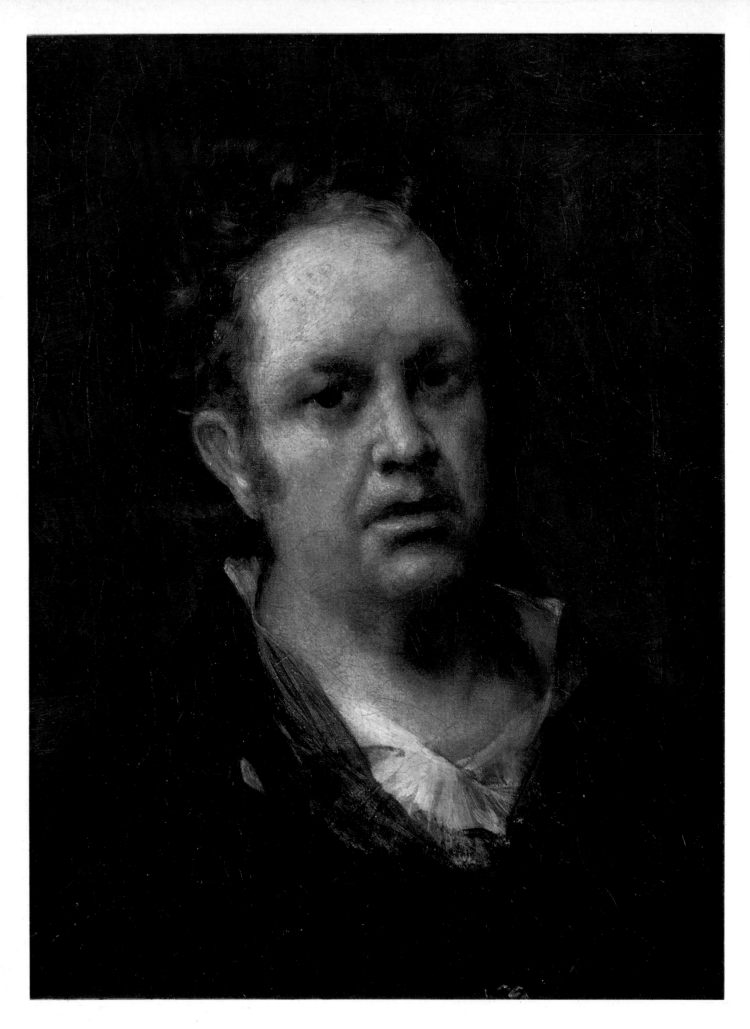

Self-portrait. About 1815. Madrid, Prado

GOYA
by Enriqueta Harris

with fifty plates in full colour

Phaidon

The author wishes to thank J. B. Trapp
for his help in the preparation of this text

© 1969 Phaidon Press Ltd · 5 Cromwell Place · London SW7

Phaidon Publishers Inc · New York
Distributors in the United States: Frederick A Praeger Inc
111 Fourth Avenue · New York · N.Y. 10003

Library of Congress Catalog Card Number 69–12788

SBN 7148 1369 9

Made in Great Britain
Text printed by Hunt Barnard & Co Ltd · Aylesbury · Bucks
Illustrations printed by Ben Johnson & Co Ltd · York

GOYA

The greatness of Goya is more widely acknowledged today than ever before. As a portrait painter, as a creator of menacing and melancholy images in oils, as a master of enigmatic, satirical and revolutionary drawing and engraving, as the champion of the Spanish people in their struggle against oppression, and the recorder of their life and customs and their sufferings in war, he is known and appreciated everywhere. Today every major collection in the world possesses some of his engravings, which were published in successive editions from Goya's own plates, the most recent being issued in 1937, during the Spanish Civil War. The two hundred and ninety-two engravings are, of course, the most portable and therefore, in the physical sense, the most accessible of Goya's works. To judge his achievement as a painter, however, one must still go to Spain itself. Most of the chief galleries of Europe and the Americas contain, to be sure, examples of his painting, and some of these represent him at his best and most characteristic. But of approximately five hundred works with any title to authenticity, nearly a third are in Madrid and almost half are preserved in Spain. No gallery outside Spain possesses more than a dozen.

Though Goya was in his lifetime the foremost painter in Spain, his fame in this medium did not extend to the rest of Europe. His only foreign patrons appear to have been the Duke of Wellington and the few Frenchmen who sat to him for their portraits – and most of these portraits were painted in Spain. He was little known abroad except as the author of the *Caprichos*. Even in Spain his reputation was in eclipse before he died. In 1828, the year of Goya's death, the catalogue of the Prado Museum in Madrid, for which he himself had provided the autobiographical note (Appendix I, 1), contained only three of his canvases. Today the Prado possesses some one hundred and eighteen pictures. He had little or no immediate influence in his own country and when he retired at the age of eighty as First Court Painter he was succeeded, not by a pupil or follower, but by an exponent of the neo-classical style, Vicente López. His move to France in the last years of his life did not, apparently, make him better known abroad. The first signs of Goya's European reputation came after his death, among the new generation of French Romantics, who were admirers, in particular, of the *Caprichos*. One of the earliest of these was Delacroix, who made copies of some of them. It was to him that the first monograph on Goya, published in Paris by Laurent Matheron, was dedicated in 1858. Before Matheron, writers such as Théophile Gautier and Baudelaire had done much to make Goya's name known as a painter as well as an engraver and the growth of *hispanisme* at that time, together with the publication in the 1860s of the *Desastres de la Guerra* and the *Proverbios*, combined to make his influence more widespread. The generations of artists who succeeded Delacroix reflect a growing admiration for the Spanish master: from Courbet to Manet and on to Picasso his presence is strongly felt. Their respect for Goya's achievement contributes as much as anything to his reputation as the forerunner of so many movements in European painting of the 19th and 20th centuries.

It is naturally for the revolutionary character of his art that Goya, the great Spanish old master, earned the title of 'first of the moderns'. But his originality can only be fully appreciated if it is seen in relation to his position as an 'official' artist and to his

conventional professional career. For during most of his life – for fifty-three of his eighty-two years – Goya was a servant of the Spanish Crown and for nearly thirty years First Court Painter to three successive Spanish Kings. Elected to the Royal Academy of San Fernando at the age of thirty-four, in 1780, he was for several years its Deputy Director and Director of Painting, with teaching duties. By far the majority of his paintings are the result of official commissions: tapestry cartoons, portraits and religious subjects. It is his official works and the public honours that he won that take pride of place in Goya's early Spanish biographies, by his son and his friend Valentín Carderera (Appendix I, 2–3). Carderera also gives a hint of the rebellious character that legend later attributed to the painter, on the evidence chiefly of his art: 'If Goya had written his life it would perhaps have afforded as much interest as that of Benvenuto Cellini'.

Modern investigations of his 'unofficial' works, particularly the graphic art, have thrown much light on Goya's critical attitude to many aspects of the contemporary world. But the mystery that still surrounds much of his life and many of his works is the result of the many gaps in our knowledge. Not enough material for a coherent and comprehensive account is yet available. Only a part of the documents relating to his official career has so far been found and only a selection of his large private correspondence is in print. One of the mysteries that is perhaps too deep ever to be solved is that first propounded by Matheron, more than a hundred years ago: 'Comme ce diable d'homme devait se trouver à l'étroit dans son costume de peintre du roi.'

Francisco José Goya y Lucientes was born on 30 March, 1746, at Fuendetodos, an Aragonese village near Saragossa, and died at Bordeaux on 16 April, 1828. The first half of his life was spent under the peaceful and relatively enlightened rule of Charles III. The second half was lived in a turbulent atmosphere of political and social unrest, which reflected and was created by the events in France that led to and followed the Revolution, in a period of foreign invasion and civil war, succeeded by a wave of reaction that led Goya eventually to seek voluntary exile in France. Goya's enormous output of paintings, drawings and engravings, produced during a working life of more than sixty years' passionate activity, record innumerable aspects of the life of his contemporaries and of the changing world in which he lived. It also reflects the personal crises which were the result of illness, in particular that which left him permanently and totally deaf at the age of forty-seven.

Not much is known of Goya's early life as a painter but it seems to have followed a conventional pattern. The son of a master gilder, he began his studies in Saragossa, at the age of thirteen, with a local artist, José Luzán, who had trained in Naples and who taught him to draw, to copy engravings and to paint in oils. In 1763 and 1766 he competed unsuccessfully for scholarships offered by the Royal Academy of San Fernando in Madrid, probably working during this time in the studio of the court painter Francisco Bayeu (Pl. 8), a fellow townsman whose sister Goya married in 1773. Unable to gain support for a journey to Italy, he went to Rome on his own account, according to his son, to continue his studies. Goya himself later asserted that he had lived there at his own expense, presumably by his brush. His meeting with the painter Jacques-Louis David, which Matheron reports Goya as having spoken of in his old age, is problematical; David was not in Italy at the time and there is no evidence that the two great contemporary artists ever met. All that is known for certain of Goya's Italian sojourn is that in April 1771 he was in Rome and from there submitted a painting to a competition held by the Academy in Parma, which had been announced in the

6

previous year. He described himself as a Roman and a pupil of Bayeu. Goya's entry, which has not survived, had for its subject Hannibal's first sight of Italy from the Alps. It won six votes and the comment that 'if his colours had been truer to nature and his composition closer to the subject it would have created doubts about the winner of the prize'. The winner was Paolo Borroni, a painter of little note today. It is not known how long Goya was in Italy. All we have to go on is his son's statement that his affection for his parents made him cut short his stay and the knowledge that by the end of 1771 he was back in Saragossa and receiving his first official commission, for frescoes in the Cathedral of El Pilar. Since there are no paintings that can be dated with certainty before 1771, it is difficult to determine what Goya learned from his visit to Italy. It is possible that he acquired the technique of fresco painting there, but against that we must set the fact that his first frescoes in Saragossa show the influence of the rococo styles of Italian artists whose works he could have seen without leaving Spain. The Neapolitan Corrado Giaquinto, for example, traces of whose style have been discerned in Goya's early work, had been active in Spain for many years and after his departure the Venetian Giovanni Battista Tiepolo had executed many commissions there. Tiepolo, with his two sons, was employed at the Spanish court from 1762 until his death in 1770. His work was one of the principal formative influences on Goya's earliest known style and it is even possible that Goya met him in Madrid before he went to Italy.

The next important influence came from a very different source, the German artist Anton Raphael Mengs, the friend of Winckelmann and celebrated exponent of neoclassicism. Mengs had gone to Spain as court painter the year before Tiepolo and when he returned there from a visit to Italy in 1773, after Tiepolo's death, he became undisputed art dictator. Indeed, according to his English translator, 'he enjoyed such fame that not to admire him was almost a violence against Church and State'. It is possible that it was in Rome that Goya first met Mengs, since many years later he wrote that it was Mengs who made him return to Spain. In any event, it was Mengs who started him on his career at court by summoning him in 1774 to work, with other young artists, on models for tapestries to be woven at the Royal Factory of Santa Barbara. Under the direction first of Mengs, and later of his brother-in-law, Francisco Bayeu, and Mariano Maella, Goya produced over fifty tapestry cartoons at intervals between 1775 and 1792.

These cartoons are important both from the point of view of the subjects represented and because of the stylistic development to which they bear witness. In the first place, they gave Goya his first opportunity to use those national subjects for which he was later so famous. Until Mengs' time the tapestries woven in Madrid had been based on literary, allegorical and peasant themes after French and Flemish paintings. Goya and his fellow artists were allowed for the first time – subject to the approval of their designs by the King – a much freer hand. Original compositions and new subjects, portraying typically Spanish scenes, now became the vogue, and we find the writer Antonio Ponz, in 1782, commending the recent tapestries based on paintings by Goya and other artists for representing 'the costumes and diversions of the present time'. These scenes of contemporary life, particularly of life in Madrid, illustrations of aristocratic and popular pastimes – *fêtes galantes à l'espagnole* – reflect the new taste for such topics which is also evident in contemporary Spanish literature, especially in the theatre. In painting Goya was to exploit them more than any other Spanish artist of his age.

It is this new subject matter which is singled out by the French Ambassador

Bourgoing, whose *Nouveau Voyage en Espagne* was first published in 1789. Goya is mentioned as one of the painters who helped to recompense the Spaniards for the loss of Mengs and is praised for the 'pleasing style in which he portrays the manners, customs and games of his country'. Mengs, in fact, had left Spain in 1776, but his presence is evident in the early cartoons, where the influence of Tiepolo's decorative style is modified by the teaching and example of the German painter, especially his insistence on simplicity and selective naturalism. In the course of his work on the tapestry cartoons, Goya developed a growing independence of foreign influences and an increasingly individual style, largely inspired by the study of Velázquez – the artist who was for Mengs the greatest exponent of the 'natural style'. About 1778 Goya made a series of eighteen etchings after paintings by Velázquez in the royal collection, which are amongst his earliest engravings. Later in life he acknowledged Velázquez as one of his three masters, the others being Rembrandt and 'above all, nature'. Rembrandt's influence, which must have come almost entirely from his etchings, is certainly visible in Goya's later drawings and engravings, but it was to Velázquez and to nature that his art owed most. Velázquez's example influenced his approach to nature and provided the model for the 'impressionistic' technique that Goya was to develop further than any artist of his age.

Nevertheless, though the later cartoons are in many respects so independent of influence from his contemporaries, they present the same baffling stylistic contradictions as the rest of his work. The cartoons, being well documented, can be dated exactly: on stylistic evidence alone, dating would be more complicated. Even late in this period of growing independence, Goya reverts to an earlier conventional manner and method of composition when the subject seems to demand it. The *Blind Man's Buff* (Pl. 12) and *El Pelele* (Pl. 10), for instance, with their stiffly posed figures with frozen expressions, are altogether less naturalistic than the *Injured Mason* (Pl. 4). The more informal the subject, the more realistically it is portrayed. Nor did Goya always take into consideration the function of the cartoons; the *Blind Guitarist*, one of his own inventions, was returned to him for alteration when the tapestry weavers found it impossible to copy.

It was probably an exaggeration of Goya's son to write that his father's extraordinary facility in painting tapestry cartoons 'astonished' Mengs. Nevertheless, Goya had certainly made an impression on his Director, for when he applied in 1776 for an appointment as Painter to the King (*Pintor del Rey*), he was recommended by Mengs as 'a person of talent and spirit who was likely to make great progress'. This good opinion did not secure Goya the appointment on this occasion or at his next application three years later, after Mengs had left Spain, even though he had the additional support then of Bayeu and Maella. He did not finally obtain the post until 1786. Meanwhile, in 1780, his application for membership of the Royal Academy of San Fernando had been unanimously approved. His admission piece was a *Crucifixion* (Fig. 3), a conventional composition in the manner of Mengs or Bayeu but somewhat influenced by the more naturalistic treatment of Velázquez, whose painting of the same subject he may have known. Shortly afterwards, Goya returned to Saragossa to paint some new frescoes in the Cathedral of El Pilar, a commission which involved him in violent altercation with the authorities and a quarrel with Bayeu, to whom he was reluctantly obliged to submit his sketches.

After his return to Madrid in 1781, Goya received the royal invitation to paint one of seven large altarpieces for the newly built church of San Francisco el Grande,

in competition with Bayeu, Maella and other court painters. Goya welcomed the opportunity to further his ambition and to prove his worth by participating in this 'greatest enterprise in painting yet undertaken in Madrid'. The invitation, he wrote to his friend and chief correspondent in Saragossa, would be the means of silencing his detractors, 'those malicious people who have been so mistrustful of my merit'. Goya made several sketches for his painting, which occupied him more than a year. The result, San Bernardino preaching, still in situ, is a conventional pyramidal composition, which is today chiefly interesting for the self-portrait which he introduced among the heads of the spectators. For Goya, it represented a personal triumph as well as a stepping stone in his career. 'Certainly', he wrote to the same correspondent, Martín Zapater, 'I have been fortunate in the opinion of intelligent people and of the public at large . . . since they are all for me, without any dissentient voice. I do not yet know what result will come from above: we shall see when the King returns to Madrid.' The King's opinion must have been favourable, for, a year after the paintings were first shown to the public – that is in 1785 – Goya was appointed Deputy Director of Painting in the Academy. In 1786 his desire to be made Painter to the King was at last realized.

Goya was now launched as a fashionable court painter and entered upon the most productive and successful period of his life. 'I had established for myself an enviable way of life,' he wrote to Zapater in 1786, 'no longer dancing attendance on anyone. Those who wanted something of me sought me out. I made myself wanted more, and if it was not someone very grand or recommended by some friend I did not work for anyone, and just because I made myself so indispensable they did not (and still do not) leave me alone so that I do not know how I am to carry out everything . . .' This was no empty boast. Anyone who was anyone appears to have wanted to sit to Goya: the royal family, the aristocracy and court officials. In 1783, he painted the portrait of the chief minister of state, the Conde de Floridablanca, in which he himself appears. In the same year he painted the family portrait of the Infante Don Luis, the King's brother, with himself again in the picture, and in the following year the court architect, Ventura Rodríguez. In 1785, he was commissioned for a series of portraits of officers of the Banco Nacional de San Carlos. In these early official portraits, Goya adopted conventional 18th-century poses, and only slightly modified the polished finish of Mengs. His portraits of society ladies in outdoor settings recall contemporary English portraits as well as his own tapestry cartoons. In such portraits as that of the Marquesa de Pontejos (National Gallery, Washington), the stiff elegance of the figure and the fluent painting of the elaborate costume reflect his study of Velázquez's Infantas. His portrait of Charles III in hunting costume is based directly on Velázquez's royal huntsmen.

Among Goya's early admirers and most important patrons during a period of twenty years were the Duke and Duchess of Osuna, who not only commissioned portraits of themselves and a family group, but also a number of paintings to decorate their country residence near Madrid, the Alameda Palace, known as El Capricho. These paintings are similar in character to the tapestry cartoons and close in style to the sketches for them but the range of subjects is wider. In addition to the genre scenes, there are some which appear to represent actual occurrences – bandits attacking a coach, a woman fainting after falling from an ass (Pl. 6) – as well as representations of witchcraft, two of which are based on scenes from plays (Pl. 19). Among other paintings for the Duke of Osuna are two altarpieces, commissioned in 1788 for the chapel of his ancestor, S. Francisco de Borja, in Valencia Cathedral, which are more dramatic in character and in treatment than any of Goya's earlier religious compositions.

9

The death of Charles III in 1788, a few months before the outbreak of the French Revolution, brought to an end the period of comparative prosperity and enlightenment in Spain in which Goya had slowly reached maturity. The rule of reaction and political and social corruption that followed – stimulated by events in France – under the weak and foolish Charles IV and his clever, unscrupulous Queen María Luisa was to end in the Napoleonic invasion of Spain.

Under the new régime Goya reached the height of his career as the most fashionable and successful artist in Spain. The new King raised him to the rank of Court Painter (*Pintor de Cámara*) in 1789 and in 1792 he felt his position in the Academy assured enough to submit a report on the study of art (Appendix II, 1), recommending the setting aside of the form of teaching established by Mengs, which had prevailed there. At the death of Francisco Bayeu in 1795, Goya succeeded his former teacher as Director of Painting in the Academy (but resigned for reasons of health two years later), and in 1799 he was appointed First Court Painter (*Primer Pintor de Cámara*). Goya evidently welcomed official honours and worldly success with almost naïve enthusiasm. 'The King and Queen are mad about your friend Goya', he wrote, announcing this last honour to his friend in Saragossa. Yet the record that he has left in paint of some of his patrons – including members of the royal family – is ruthlessly critical.

During a visit to Andalusia towards the end of 1792, Goya was struck down by a long and serious illness of which the effect, even a year later, made him, he wrote, 'at times rage with so ill an humour that he could not tolerate himself.' The nature of the illness is not known for certain but it caused temporary paralysis and partial blindness and left him permanently deaf, so that henceforth he could only communicate by writing or sign language. He returned to Madrid in the summer of 1793 and in the following January sent a series of eleven small paintings to Bernardo de Iriarte, Vice Protector of the Academy, with a covering letter in which he wrote: 'In order to occupy an imagination mortified by the contemplation of my sufferings and to recover part of the very great expense they have occasioned, I devoted myself to painting a group of cabinet pictures in which I have succeeded in making observations for which there is normally no opportunity in commissioned works, which give no scope for fantasy and invention.'

Of these eleven pictures of various 'popular diversions' it is not possible to say much. They were shown, we know, at a meeting of members of the Academy, who expressed approval of them. Their subsequent history is not known, but there are in the Academy today five paintings which probably correspond to five of them (see Pls. 11, 13-15). These five were not presented to the Academy in Goya's lifetime, but since the painter had asked that the pictures should be sent on to another patron after they had been seen at the Academy, this does not tell against the identification. Nor does the argument that one of the five shows an Inquisition scene and that this would have been an unlikely subject for Goya to paint while the Inquisition was still active in Spain. Such a scene was no more daring than those shown in many of the *Caprichos* which he was to publish within a few years. Stylistically, the five putative survivors of the original group represent a new departure. Their free sketchy technique with bold splashes of colour and black outline, foreshadowing Goya's later style, need not indicate a late date for them. The lack of a consistent stylistic development has already been remarked on in relation to the tapestry cartoons, and this inconsistency is present throughout Goya's works. Thus it is permissible to see these pictures as a further step in the increasing variety of his manner. His range of subject, too, was widening in all three media –

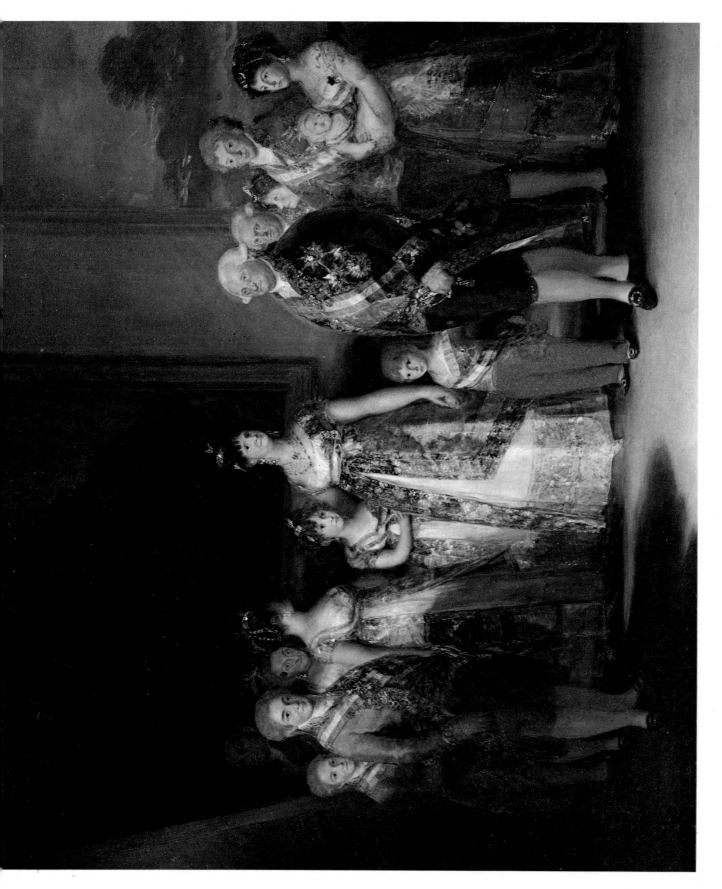

Charles IV and his Family. 1800. Madrid, Prado

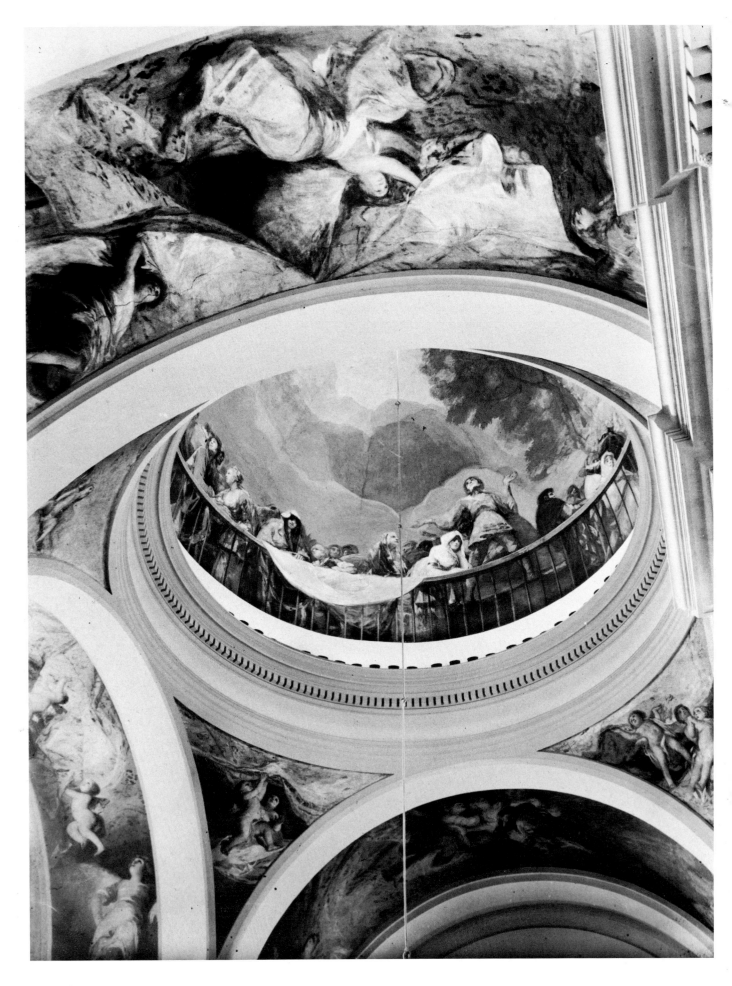

Fig. 1. **Madrid, Church of San Antonio de la Florida:** interior, looking up into the cupola

painting, drawing and engraving. From now on uncommissioned works give full scope to 'observation', 'fantasy' and 'invention'. For his commissioned works Goya continues to use conventional formulas.

In the years after his illness Goya produced some of his most sensitive and delicately painted portraits – the silvery-toned likenesses of his brother-in-law, Francisco Bayeu (Pl. 8), Andrés del Peral (Pl. 24), the intimate yet formal portrait of his friend and protector, the liberal Minister and writer, Gaspar Melchor de Jovellanos (Private Collection, Madrid), for instance. The characterization of the heads, which is so notable in these paintings, is surprisingly absent in the two delicately but stiffly painted portraits of the Duchess of Alba, of the same period. In each case the face of the Duchess, famous for her beauty, is that of a painted doll; there is no hint in the execution of the portrait of 1797 (Pl. 9), for example, of the probable intimacy between the artist and the sitter. On the contrary, it is carefully veiled: only the inscription, recently uncovered, to which she points seems to indicate the nature of the relationship. Yet at the time when he painted this portrait, during his stay at her Andalusian estate after her husband's death, Goya was recording, in a sketchbook, many lively, intimate scenes in the everyday life of the Duchess and her household.

At about this time Goya was also making drawings for a very different purpose, the series of eighty etchings published in 1799, called *Los Caprichos*. In these the artist used the popular imagery of caricature in a highly original and inventive form for his first venture in the criticism of political, social and religious abuses, for which he is famous. His mastery of the recently developed technique of aquatint makes these etchings also a major achievement in the history of engraving. Despite the veiled language of the *Caprichos* they were withdrawn from sale after a few days. Yet, in one of those apparently inexplicable contradictions in which the life of Goya abounds, when the plates and surplus copies were offered to the King in 1803, they were accepted and Goya was rewarded with a pension for his son. Many years later, Goya spoke of having nevertheless been denounced to the Inquisition – at what date and with what consequences we do not know.

What we do know is that only a few months after the publication of the *Caprichos* Goya was promoted to the rank of First Court Painter. Whether or not they were withdrawn for political reasons, Goya's success and official position with his royal patrons appears to have been unaffected at the time either by the *Caprichos* or by his increasingly unconventional treatment of conventional subjects. His fresco decorations in the Church of San Antonio de la Florida, a royal commission executed in 1798, in the space of a few months (Fig. 1, Pls. 16 and 20), owe little to earlier religious frescoes. The over life-size figures are painted in a broad free style, in strong colours, with hardly any detail, that has no precedent in Goya's oeuvre (unless the much smaller 'popular diversions' in the Academy were painted during his convalescence in 1793). Though Goya in this same period was painting religious subjects such as the *St. Gregory* (Pl. 5), and the *Taking of Christ* in the Sacristy of Toledo Cathedral (Fig. 5) in conventional terms, here he has concentrated on the overall decorative effect. The *Miracle of St. Anthony*, the central theme, is almost overshadowed by the surrounding populace and by the angels in the shape of women below.

Even less conventional than the San Antonio frescoes are Goya's portraits of his royal patrons. From the time of their accession until 1800, Charles IV and María Luisa sat to him on many occasions, and many replicas were made of his portraits. He painted them in various costumes and poses, ranging from the early decorative portraits

in full regalia in the earlier tradition of Mengs to the simpler and more natural compositions in the manner of Velázquez, who directly inspired the large equestrian portraits in the Prado Museum. But while following traditional compositions for these state portraits, Goya creates an effect of pomposity rather than majesty and the faces of his sitters reveal a penetrating scrutiny of character. Nowhere is this more striking than in the portrait of *Charles IV and his Family* (Plate in text and Pl. 17). Though Goya doubtless had in mind Velázquez's unique royal portrait group, *Las Meninas*, which he had copied in an engraving years before, his royal assembly lacks any semblance of courtly dignity and elegance. Moreover, despite the official character of the painting and his official position, he has accentuated the ugliness and vulgarity of the principal figures so vividly as to produce an effect almost of caricature. Théophile Gautier, writing of this picture, remarks that the King 'looks like a grocer who has just won the lottery prize, with his family around him'.

Goya as First Court Painter seems to have been more ready than ever to express an opinion of his sitters in his portraits of them. The portrait of the Countess of Chinchón (1800), for example, is a sympathetic portrayal of the young pregnant wife of Manuel Godoy, 'Prince of the Peace' and Chief Minister, the lover of Queen María Luisa. Godoy's own portrait (1801) is a somewhat theatrical composition, which may hint at the disrespect that was almost certainly intended in several plates of the *Caprichos*. Godoy was, nevertheless, an important patron of the artist. His palace was decorated with allegorical paintings by Goya, he not only sat to him on more than one occasion for his portrait but had his wife painted by him and he owned versions of Goya's portraits of the King and Queen. It is, moreover, in Godoy's collection that the *Maja desnuda* (Pl. 22) and the *Maja vestida* (Pl. 23) are first recorded, and the importance of his position makes it possible that they were painted for him. The possibility is strengthened by his known taste – he owned among other such pictures Velázquez's 'Rokeby Venus' – but it cannot be asserted that he actually commissioned Goya's only painting of a female nude. Both the origin of the *Majas* and the identity of the model are still a mystery. Goya was summoned by the Inquisition in 1815 to explain when and for whom they had been executed, but his explanation has never been discovered.

At about the same time when the *Majas* were probably painted, i.e. before 1803, Goya seems to have suffered a loss of royal favour. The group portrait is the last occasion on which he painted either Charles IV or María Luisa, and in 1804 he was unsuccessful in his application to be made Director General of the Academy. The decline in favour has never been satisfactorily explained, though a variety of reasons have been advanced for it. Among these are the notoriety of the *Caprichos* (Goya's gift of the plates to the King in 1803 is thought by some to have been an attempt to protect himself); Goya's political sympathies (his protector Jovellanos was imprisoned in 1801); his liaison with the Duchess of Alba and the circumstances of her death in 1802; the change of taste exemplified in the appointment of Vicente López as Court Painter in 1802. The true cause may well be a royal preference for López's more flattering, neo-classical style of portraiture.

Despite his loss of official patronage, the years preceding the French invasion were for Goya prosperous and fruitful. He was rich enough to purchase a second house which he gave to his son, Francisco Javier, the only surviving child of several – though not of the legendary twenty – on his marriage in 1805. Goya's production consisted chiefly of portraits but these were of a wider range of sitters than hitherto: his son and daughter-in-law, men and women whose names are known today only because he painted them,

14

others whose names have been forgotten, as well as some members of the court and aristocracy. In 1805, perhaps a few years after the *Majas*, he painted in a similar pose the Marquesa de Santa Cruz, daughter of his earlier patrons, the Duke and Duchess of Osuna, a young woman said to have had a taste for the unconventional. But though she is more lightly clothed than the clothed *Maja*, her attributes of wreath and lyre and the more polished style of the painting produce a more formal effect. Goya's uncommissioned works of this period include two paintings of *Majas on a balcony*, recorded in the artist's possession in 1812.

Goya was sixty-two years old when the old régime in Spain finally collapsed, with the aid of Napoleon, and Spain was subjected to six years of war and revolution. The rapidity and confusion of the events of 1808, when the French crossed the frontier are, as it were, reflected in the history of the equestrian portrait of Ferdinand VII (Madrid, Academy of San Fernando). Goya was ordered to paint this portrait in March, after the rising at Aranjuez, which had forced the resignation of Godoy and the abdication of Charles IV. Only three sittings of three-quarters of an hour were allowed him and the picture was not exhibited until October of that year. In the meantime Napoleon had forced Ferdinand from the throne in favour of his own brother Joseph and the French had entered and been temporarily expelled from Madrid.

Goya's conduct and his continued practice in his profession during the war were in some ways equivocal but in this he was no different from many of his fellow-countrymen and friends. He was in Madrid during the tragic events of the 2nd and 3rd May when the populace rose against the French and the rising was savagely repressed – events which he later recorded in two of the most famous of his paintings (Pls. 30 and 31). After the temporary liberation of the capital he was summoned by General Palafox to Saragossa, his home town, which had recently been under siege, to inspect the ruins and record the glorious deeds of its inhabitants. He is next heard of in Madrid towards the end of 1808, when the French were again in occupation, and with thousands of other heads of families Goya swore allegiance to the French King. He also seems to have resumed his activities as Court Painter and was awarded Joseph's decoration, the Royal Order of Spain, in March 1811. Goya was one of three academicians ordered by Joseph to select fifty Spanish pictures from palaces and churches for the Musée Napoléon in Paris and seems to have done so only after long delay. When the pictures reached Paris it was reported that at the most six were worthy to enter the Museum. During the French occupation Goya painted the *Allegory of the City of Madrid* (Pl. 32), with a portrait of Joseph which he copied from an engraving. There is no record of Joseph's sitting to Goya, though several French generals and pro-French Spaniards did so. As soon as Wellington entered Madrid in 1812, Goya accepted a commission for an equestrian portrait of the liberator and, probably soon afterwards, painted two other portraits of his only recorded English sitter (Pl. 29). During the war he was also occupied with family portraits and portraits of private citizens. His uncommissioned works of the period include many paintings of the hostilities themselves and one symbolic picture, the fearful and enigmatic *Colossus* (Pl. 27). But the most moving and eloquent record that he made of the war and of his personal reactions to it are the *Desastres de la Guerra*, a series of eighty-two etchings for which he made drawings at the time, though they were not published until 1863. If at any time Goya had looked upon the French as liberators, the *Desastres* express his fierce hatred of the effects and consequences of war, just as other drawings of the period bear witness to a more generalized but no less fervent abhorrence of injustice, oppression and hypocrisy.

15

At the end of the war Goya and other Spaniards who had served the French King were subjected to 'purification'. Goya defended himself by claiming that he had never worn Joseph's decoration and that it had only compromised him, several witnesses supporting this statement. His defence was accepted and Goya resumed his office as First Court Painter on the restoration of Ferdinand VII. Even before the King's return, he had applied to the Regency for permission to commemorate the incidents of the 2nd and 3rd May (Pls. 30 and 31). Soon afterwards he was commissioned to paint several portraits of the King for ministries and other public buildings. For these, Goya seems to have used the same study of the head, changing only pose, setting and costume to suit the occasion. The portraits (see Pl. 33) are remarkable for a characterization that comes even closer to caricature than the portraits of María Luisa: their pompous attitudes and subtly exaggerated facial expression evoke the cruel, despotic character of the *rey deseado*, whose restoration to the throne inaugurated a new era of fanaticism and oppression. The portraits of Ferdinand were Goya's last royal portraits, apart from the appearance of the King in the *Royal Company of the Philippines* (Musée Goya, Castres). Goya was again out of favour. Whether or not his image of the King was felt to be objectionable, Ferdinand clearly preferred the more pleasing style of Vicente López for portraits of himself and family.

It may be too that Goya's liberal sympathies did not recommend him at Court. Ferdinand's reactionary measures immediately after his restoration, his repudiation of the Constitution of 1812, the re-establishment of the Inquisition, the closing of universities and theatres, the introduction of press censorship and the persecution of the liberals, including many of Goya's friends, must certainly have antagonized the artist. Although he was exonerated from the charge of having 'accepted employment from the usurper' in April 1815, in the following month he was summoned to appear before the Inquisition on account of the *Majas*. Nevertheless, Goya retained his position as First Court Painter for another decade.

Apart from the publication, in 1816, of the *Tauromaquia*, a series of etchings of the national sport of bullfighting, Goya from now on was chiefly occupied with paintings for private patrons, for friends and for himself. He also continued to record in the more intimate medium of drawing his observations and ideas. Freed from official restrictions, his style became more and more personal and his technique increasingly free and impressionistic as in the *Woman reading a letter* (Pl. 38) and the *Forge* (Pl. 39). A similar development is visible in the gradually changing style of the portraits he painted at this time. The poses, except in the case of a few official sitters, become less formal and Goya develops his technique of creating a remarkable effect of likeness by means of a minimum of detail. Pose and technique are strikingly illustrated in the self-portrait with his doctor painted in 1820 to commemorate his recovery from serious illness the year before (Fig. 6). Goya shows himself supported in the arms of the physician, the melancholy expression that he had worn in the self-portrait of 1815 (Frontispiece) now deepened and transmuted by suffering.

It is perhaps surprising that during this period of semi-retirement Goya should have received two important ecclesiastical commissions, for the *St. Justa and St. Rufina*, painted in 1815 for Seville Cathedral, and for the *Last Communion of St. Joseph of Calasanz*, painted in 1819 for the church of the Escuelas Pías de San Antón in Madrid (Fig. 4). In these he adapted his late style to traditional subject matter and turned to seventeenth-century Spanish painting for his models. While the Seville picture has been criticized for its profane character, the *Last Communion* is more

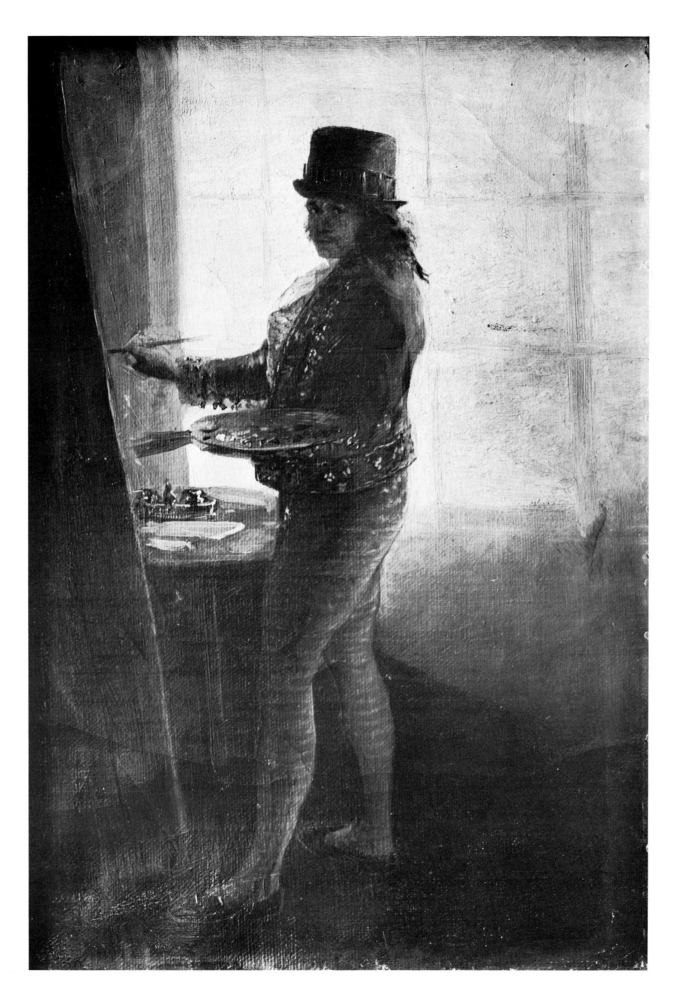

Fig. 2. **Self-portrait.** About 1786. Madrid, Villagonzalo Collection

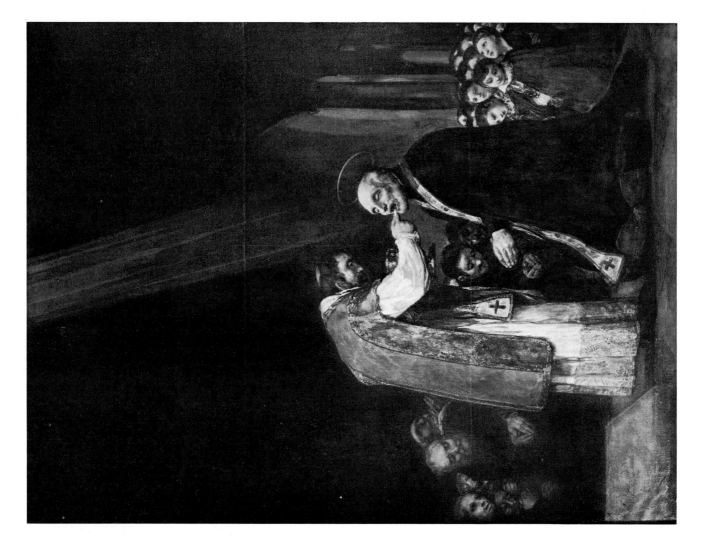

Fig. 4. **The Last Communion of St. Joseph of Calasanz.** 1819. Madrid, Church of the Escuelas Pías de San Antón.

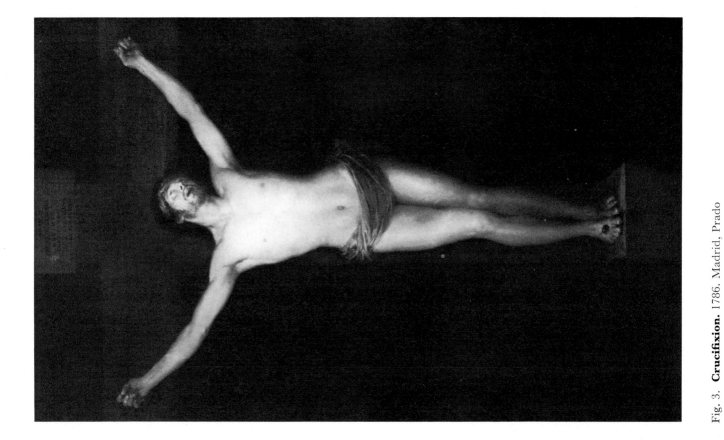

Fig. 3. **Crucifixion.** 1786. Madrid, Prado

Fig. 6. **Self-portrait with Dr. Arrieta.** 1820. Minneapolis, The Institute of Arts

Soya agradecido, á su amigo Arrieta: por el acierto y esmero con q.ᵉ le salvó la vida en su aguda y
peligrosa enfermedad, padecida á fines del año 1819. á los setenta y tres De su edad. Lo pintó en 1820.

Fig. 5. **The Taking of Christ** (detail). 1788-1789. Toledo Cathedral, Sacristy

Fig. 7. **A Half-naked Woman Leaning on a Rock.** Miniature on Ivory. 1824-1825. Boston, Museum of Fine Arts

Fig. 8. **Majo and Maja.** Miniature on Ivory. 1824-1825. Stockholm, Nationalmuseum

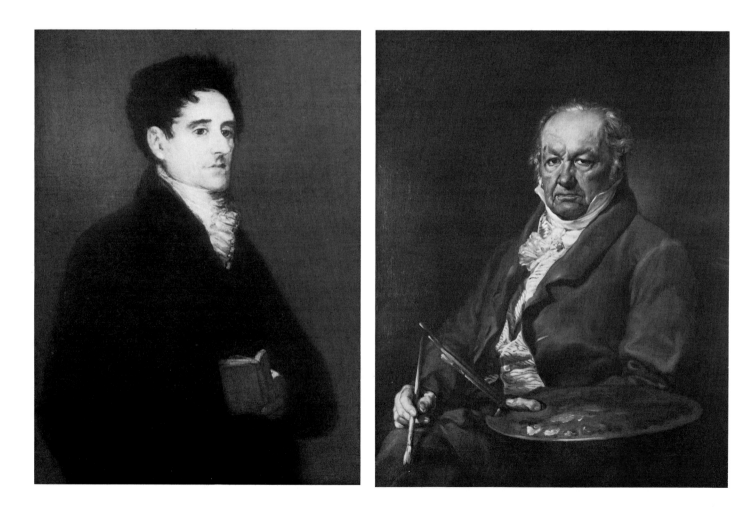

Fig. 9. **Portrait of Joaquín María Ferrer.** 1824. Rome, Lagandara Collection

Fig 10. **Vicente López: Portrait of Goya.** 1826. Madrid, Prado

suggestive of religious devotion than any of Goya's earlier religious works.

No hint of anything so conventional is apparent in the famous 'black paintings' now in the Prado (Pls. 42–45), the terrifying images with which he decorated his house on the outskirts of Madrid, the *Quinta del Sordo*. These paintings must have been executed between 1820, after his illness, and 1823 when Goya made over the *Quinta* to his grandson. Their entirely new, expressionist language and grim fantasy make them, along with the *Proverbios* or *Disparates* (a series of etchings made about the same time, though not published until 1864) the most private and tortuous of all his works. Their subjects, sinister, horrific and mysterious, and their atmosphere of nightmare seem the product of cynicism, pessimism and despair. Paradoxically, the period of their painting corresponded to a liberal interlude, forced upon Ferdinand by widespread revolt, but lasting only three years. When the French army restored the King to absolute power in 1823, the persecution of the liberals was renewed with greater violence than ever before. Goya, who had made his last appearance at the Academy on 4 April, 1820 to swear allegiance to the Constitution, went into hiding early in 1824. Many of his friends had already left the country or were in similar concealment. After the declaration of amnesty of that year, he applied for in May – and was granted – leave of absence to travel to France, allegedly to take the waters at Plombières for his health. He went first to Bordeaux, where several of his friends had settled, arriving there in June, according to one of them 'deaf, old, slow and feeble – and so happy and so eager to see the world'. From Bordeaux he went on to Paris, where he spent two months in the company of Spanish refugees, leaving the house, according to the police record 'only to see the sights of the city and to roam the streets'. Back in Bordeaux, Goya set up house with Leocadia Weiss, who had come from Spain with her two children, for the younger of whom he is known to have had a special affection. He taught her to draw and had great, but unfulfilled, hopes of her talent.

Goya remained in Bordeaux for the rest of his life, except for two short visits to Madrid in 1826 and 1827. On the former he offered his resignation as First Court Painter and was pensioned off. 'I am eighty years old', he wrote to the King, 'I have served your august parents and grandfather for fifty-three years.' During the visit he sat to Vicente López, his successor (Fig. 10).

Until the end of his life Goya, in spite of old age and infirmity, continued to record the world around him in paintings and drawings and in the new technique of lithography which he had already begun to use before leaving Spain. 'Sight and pulse, pen and inkwell, everything fails me and only my will is to spare', he wrote to his friend Joaquín Ferrer (Fig. 9) in Paris in December 1825. But even now he was turning to something new. In the same letter, evidently a reply to a suggestion that the *Caprichos* would be saleable in Paris, he announced that he had 'better things today which could be sold to greater effect. To be sure', he continued, 'last winter I painted on ivory a collection of nearly forty examples, but it is original miniature painting such as I have never seen for it is not done with stippling and they look more like the brushwork of Velázquez than of Mengs.' A number of these miniatures have survived and are indeed original in subject-matter, style and technique. Instead of the usual portraits, Goya shows such subjects as a young woman, half-naked, leaning on a rock (Fig. 7), a monk talking with an old woman, a *majo* and *maja* (Fig. 8). Instead of the careful finish usual in miniatures, we have the broad sketchy style of Goya's last years. His technique, so different from that of the conventional miniaturist, is described by Matheron, whose information about Goya's years in Bordeaux is based on the first-hand evidence of the

artist's companion and compatriot, Antonio Brugada: 'He blackened the ivory plaque and let fall on it a drop of water which, as it spread, lifted off part of the black ground and traced chance lines. Goya made use of these furrows and always brought out something original and unexpected. These little productions belong to the same family as the *Caprichos*.'

During these last years in Bordeaux, Goya painted a number of still-life subjects (Pl. 47), observed, according to Matheron, in the market-place and executed on his return home, 'in a hand's turn, between two cigarettes'. A few genre subjects and some portraits of his friends complete the catalogue of his paintings. The genre scenes of the year before Goya's death – the *Milkmaid of Bordeaux*, the *Head of a Monk* and the *Head of a Nun* – are difficult to categorize. Like many of his earlier uncommissioned works, they seem to belong neither to genre proper, nor to religious painting, nor to portraiture. The portraits of Santiago Galos (1826, Barnes Collection, Philadelphia), Juan de Muguiro (1827, Prado), José Pío de Molina (1828, Reinhardt Collection, Winterthur) are the most remarkable illustrations of the final development of his style. 'There again,' writes Matheron, who had seen weakness of touch and uncertainty of drawing in the still-life and other late paintings, 'before the living model, a double *binocle* on his nose, he found himself again for a brief space.'

The free handling of form and colour in these last paintings, the assurance with which they achieve their effect in terms of light and shade, without outline or detail and in a narrow range of tones, make them today among the most admired of Goya's works. Nearly forty years before he painted them, in 1792, Goya had announced his credo: 'There are no rules in painting. . . . Even those who have gone furthest in the matter can give few rules about the deep play of understanding that is needed, or say how it came about that they were sometimes more successful in a work executed with less care than in one on which they had spent most time. What a profound and impenetrable mystery is locked up in the imitation of divine nature, without which there is nothing good. . . .' In his old age, Matheron reports, he mocked the academicians and their methods of teaching: 'Always lines, never forms', he is reported to have said in one of his rare conversations about painting. 'But where do they find these lines in nature? Personally I only see forms that are lit up and forms that are not, planes which advance and planes which recede, relief and depth. My eye never sees outlines or particular features or details. I do not count the hairs in the beard of the man who passes by any more than the buttonholes on his jacket attract my notice. My brush should not see better than I do.' And again: 'In nature, colour does not exist any more than lines. There is only light and shadow. Give me a piece of charcoal and I will make you a picture. All painting is a matter of sacrifice and *parti-pris*.' The reduction of Goya's palette had come slowly and step by step with his abandonment of academic style. The brightly coloured and decorative tapestry cartoons, with which his career was launched, belong to another world and an earlier century. It is the works of his maturity and old age, varied, penetrating, sombre, melancholy, violent, technically audacious, which made Goya's reputation as the greatest master of his age and the first of the moderns. Our last records of Goya's life are letters to his son in which he expresses his joy at the prospect of a visit from his grandson and daughter-in-law and his impatience to see them. They arrived on 28 March, shortly before Goya wrote his last lines to his son: 'I can only say that such joy has made me a little indisposed and I am in bed.' A few days later he suffered a paralytic stroke and died on 16 April, 1828.

Appendix I

Early biographies of Goya

1. Autobiographical notice in the catalogue of the Prado Museum, published on its reinauguration in 1828.

Goya (Francisco): Born in Fuendetodos, kingdom of Aragon, he was named the King's Court Painter in 1780 and later First Court Painter; now pensioned off because of his advanced age.

He was a pupil of don José Luzan in Saragossa, who taught him the principles of drawing, making him copy the best prints that he had. He was with him for four years and began to paint from his own invention until he went to Rome, having had no other master than his observation of the famous painters and paintings of Rome and Spain, which is what most benefited him. (Article communicated by the artist.)[1]

2. Biography by Goya's son, Francisco Javier [1831].

Don Francisco de Goya y Lucientes was born in Fuente de Todos in the kingdom of Aragon on 31 [30] March 1746. He was baptized Francisco José.

He studied drawing in the Academy of Saragossa and after he had acquired some knowledge of working in oils he went to Rome where he studied, not as a pensioner of the court of Madrid – there were several of them at that time – but with the application proper to one who is supported only by his family. The blind affection that he had for his parents made him return all the quicker to his country and he was never separated from them again.

The first works which made his genius known were the pictures that he painted for the Royal Tapestry Factory, and his extraordinary facility astonished *Caballero* Mengs, under whose inspection they came. It is not easy to enumerate the pictures of his first period. However, careful examination of the *Crucifixion* which hangs at the entrance to the choir in the convent of San Francisco el Grande in this court, for which he was made *Académico de mérito* in painting on 7 May 1789 [1780; Fig. 3], makes it obvious that he must already have painted a great deal to arrive at the stage necessary to gain this distinction. He was most felicitous in his portraits and those which he painted in a single session have won most general approval.

He painted only in one session, sometimes of ten hours, but never in the [late] afternoon. The last touches for the better effect of a picture he gave at night, by artificial light.

He mistrusted his productions and on one occasion when somebody went against him he said: 'I have forgotten how to paint.' He won the special esteem of the monarchs Charles III, IV and Ferdinand VII, being named Court Painter on 25 April 1789 and First Court Painter on 31 October 1799 on account of the effect produced on Their Majesties by the portraits which he made (now hanging in the Royal Palace and Museum of Paintings) and he received at that time very special marks of favour from Their Majesties.

[1. *Noticia de los cuadros . . . del Museo del Rey . . . en el Prado de esta Corte*, 1828, p. 67.]

He looked with veneration at Velázquez and Rembrandt, but above all he studied and looked at Nature, whom he called his mistress. What contributed not a little to this was that he lost his hearing at the age of forty-three [forty-seven].

He drew a great deal, especially in his last years and has left four suites of etchings, of which the only one known is that sold at His Majesty's Chalcography under the title of *Goya's Caprichos*. This work, which he engraved about 1796–97, is the one for which he is famous in the principal capitals of Europe. It has won praise for its artistic merit and satirical ideas, which do honour to the enlightenment of Spaniards at that time.

His health, which declined after 1822, obliged him to go to Paris with royal permission in 1824. He remained in France, dying in Bordeaux on 16 April 1828. In his few productions of these last years, no weakness, such as usually occurs with the failing of physical powers, is evident.

The pictures which he made for the church of Monte-Torrero in Saragossa, those for Valencia Cathedral, the *Taking of Christ* in Toledo [Cathedral: Fig. 5], the *Virgin* in the church of the town of Chinchón, *Saints Justa and Rufina* in Seville [Cathedral], a *St. John and St. Francis* for America, the *Venuses* [*Majas*, Pls. 22, 23] which belonged to the Prince of the Peace, the equestrian portraits of the Duke of Wellington and of His Excellency General Palafox, and some portraits such as that of Her Excellency the Marquesa de Santa Cruz and several others, most particularly those which he kept in his own possession – [all] demonstrated plainly that there remained nothing for him to conquer in Painting and that he knew the magic (an expression which he always used) of the atmosphere of a picture.

He painted in fresco in Saragossa and San Antonio de la Florida [Fig. 1, Pls. 16 and 20].[2]

3. Biography by Goya's friend Valentín Carderera, published in 1835.

Until some other pious pen, as Vasari says, and one more elegant and expert than ours proposes to write the life of the [most] original artist of the last half of the last century and a good part of the present one, we believe that art lovers will not be ungrateful for this slight sketch of his life and of his beautiful productions.

Don Francisco Goya y Lucientes was born in Fuente de Todos in the kingdom of Aragon on 31 [30] March 1746.

He learnt the first rudiments of art in the Academy of San Luis in Saragossa. After acquiring some knowledge of working in oils, he was drawn to Rome by his passionate love of painting and studied there not as a pensionary of the court of Madrid, of whom there were several at that time, but with the application proper to one who counts on no other help than that offered by his family.

Fortunate is he who, conscious of and obedient to his own talents, does not allow himself to be swayed by the example of the masses or by the doctrines and preoccupations of his contemporaries; but who, on the contrary, follows his vocation, strong to perfect himself in it and battling towards his goal. Such was our Aragonese artist who, having studied with admiration famous ancient works assembled in that metropolis

[2. P. Beroqui, 'Una biografía de Goya escrita por su hijo', *Archivo Español de Arte y Arqueología*, III, 1927, pp. 99–100. The longer of two biographies by Goya's son. The shorter version, dated 1831, is printed in *Goya: Colección de cuadros y dibujos precedida de su biografía y de un epistolario*, pub. Calleja, 1924, p. 60.]

of the arts, was as gifted as to follow a very different path from that of nearly all the many painters who studied in that capital. Artists like [Sebastiano] Conca and [Francesco] Trevisani had so infected Italy and all the most civilized parts of Europe with that mannered and corrupt style derived from such artists as [Pietro da] Cortona and [Ciro] Ferri that there was hardly an artist who did not glory in imitating it and thereby suppressing that germ of merit or talent which Nature is accustomed to distribute to everyone.

Goya's stay in Rome was not very long. He returned to his own country because of the extraordinary affection he always had for his parents, from whom he was never again separated.

The first works that made his genius known were the pictures for the Royal Tapestry Factory. The taste, talent and above all the extraordinary speed with which he executed them attracted the attention of *el caballero* Mengs who was inspector of paintings for tapestries for the Royal Palace. All the *aficionados* know the grace and natural ease with which he represented the popular scenes of our country, a genre in which he particularly excelled. His spirited and very fertile genius directed his brush and there exist admirable easel pictures in which he improvised innumerable *caprichos*, products of the most lively fantasy. This his first period is notable for the simplicity and naturalism of his compositions, the lighting and unforced effects of the chiaroscuro. All his productions, though less lively than those of his best period, have a truthfulness that is enchanting.

To this first period and style belong – though we do not know exactly when they were executed – the large picture which he made for the church of San Francisco el Grande in this Court [of Madrid]; many bullfights and popular scenes on a small scale, amongst them the very notable examples in the casino of the *alameda* of His Excellency the Duke of Osuna, Count of Benavente, and others that he made for D. Andrés del Peral. A large picture of all the family of His Serene Highness, the Infante D. Luis which belongs to the Count and Countess of Chinchón; the full-length portrait of the Count of Florida Blanca in which he also portrayed himself; the portrait of the Duchess of Alba, also full-length [Pl. 9] and above all a very beautiful *Crucifixion* [Fig. 3] which hangs in the entrance to the choir of the above mentioned convent of San Francisco el Grande, for which he was nominated *académico de mérito* of the Royal Academy of San Fernando on 7 May 1780.

His second manner begins a new and very distinguished epoch in the history of our painting. The continual study of Nature and the close observation of the works of the great Velázquez and of Rembrandt formed that style which is the delight of intelligent people and *aficionados*. From the Dutch painter our artist learned that great economy which he used in the lights of his pictures so as to create that piquant and emphatic effect that surprises and pleases even the most ignorant. From the famous Sevillian he took his admirable understanding of aerial perspective, that effect of vapour or interposed air which characterizes all the pictures of his second and last period, that bold and firm execution and, finally, that special touch with which the great Velázquez summarily indicated details in the attempt to direct the spectator's eye to the principal subject without allowing irrelevant accessories to distract his attention.

Goya painted the illuminated parts with a great mass of colour without mixing it. He reflected on and calculated the effect beforehand and, once he had decided on how to achieve it, he made his stroke with such ease and daring that the result was admirable, although to those of little understanding many of his principal works appear to

have been made hastily and negligently. He had such care and love for the grand effect of a picture that he usually put the last touches of light on by night with artificial light, at times taking little account of whether the drawing was more or less correct.

Thus we are astonished by the two beautiful pictures of San Francisco de Borja, which he made for Valencia Cathedral, the *Taking of Christ* in the sacristy at Toledo Cathedral [Fig. 5]; the *Virgin* in the church of the town of Chinchón and above all the magnificent picture in which he represented the *Royal Family of Charles IV*,* full-length, where he portrayed himself in the act of transferring to canvas that august group [Plate in text]. The King and Queen were highly admiring of and satisfied by this production and showed their royal pleasure by appointing him their first painter on 31 October 1799 [the family portrait was painted after this appointment] having already made him *pintor de cámara* from 25 April 1789 for the other excellent full-length portraits that he made of Their Majesties.

Not all the works of his last period were affected by the decline of his physical forces. The canvas in which he portrayed himself on his death bed, at the moment when the distinguished Professor Arrieta was giving him the draught which restored him to his country and to his numerous admirers, is a work that recalls all the vigour and mastery of his best years [Fig. 6]. His likeness of himself in agony and the physiognomy of the doctor, animated by the most beneficent expression, are drawn and coloured with the greatest mastery. Throughout the work it seems that Goya was trying to rejuvenate his talent in order to show the extent of his gratitude. The picture of the *Communion of St. Joseph of Calasanz* in the church of S. Anthony Abbot in the Court [of Madrid] is a combination of very distinguished qualities [Fig. 4]. The scene is perfectly imagined and the effect extremely forceful. Perhaps he made too much use of printers' black, for he blackened excessively a great part of the pictures of his last period. This and the loss of firmness inevitable at such an advanced age, made some of his canvases appear less beautiful. But the effect was always piquant and vigorous, as can be seen in the picture of *Saints Justa and Rufina* which he made for the Cathedral of Seville.

His health, which had been declining since 1822, obliged him to undertake, with royal permission, a journey to Paris in 1824 and after that he always remained in France and died in Bordeaux on 16 April 1828.

Goya had perfect mastery in the exercise of his art, whether in oil painting, tempera or fresco. Very notable works in this last medium are the paintings of the smaller cupolas of the Metropolitan del Pilar in Saragossa; of the whole ceiling and lunettes in the church of San Antonio de la Florida [Fig. 1, Pls. 16 and 20], and in a country house near the Manzanares which belongs to his son [Pls. 42–45].

His excellent handling of oil paint is well known; he never descended to minute details in his canvases, or with palette or brush. For the brush he sometimes substituted the flexible point of his palette knife and his palette was so simple that he ordinarily used nothing but vermilion, ochre, white and black.

He had an astonishing facility in portrait painting. He customarily painted portraits in a single session and these were the most life-like. We owe to his brush a very great number of portraits, for everybody coveted the honour that Goya conferred [on them] by his own celebrity. Thus he also left us very lively likenesses of many great men who are an honour to our nation. Many of them still seem to breathe; their forms and colour are so correct and true, their individual postures so natural that we can guess their disposition and character. The portraits of the Infante D. Luis and Wife, general

* Today the picture hangs in the room in the Museum where Their Majesties rest.

Urrutia, the Duchess of Alba [Pl. 9], Azara the naturalist, the architect Villanueva, Moratín, Máiquez and very many others who for lack of space cannot be named in this journal prove the truth of what has been said.

He drew a great deal during his last years; some drawings of his best period are very finished and executed with great love and understanding of anatomy, confirming that the slight faults in this respect which can be seen in some of his works are due to the fire and enthusiasm with which he painted in neglect of this aspect and rejection of fixed academic and systematic rules. He used to say that only Nature was his master; for, having been left completely deaf at the age of forty-three [forty-seven], he gave himself up wholly to the constant study of this great book.

All the art world knows his charming etchings. In addition to his collection of 80 *caprichos*, which he worked on around 1796–7, he made a great many engravings both from the principal pictures of Velázquez, and from his own compositions. All of them are to be admired for their highly original invention, for a chiaroscuro that is ingenious and surprising though not always according to rule, and a touch often so lively and delicate that the engravings recall not a little the highly esteemed works of Rembrandt, [Stefano] della Bella, and others eminent in this art.

The *Caprichos*, already mentioned, and other single compositions both in painting and engraving, reveal his satirical spirit, his lively understanding, his enlightenment and also a certain greatness of spirit which enabled him to ridicule and criticize the vices and excesses of people who at the time were extremely powerful.

And in order that he should not be ignorant of any medium he also wanted to make lithographs and thus he made a series of bullfights, his favourite diversion, and some other single caprices.

The new romantic school of French painters has made evident the merit of our artist, and in a number of small pictures and in very many lithographs and etchings which decorate the editions of Victor Hugo and other celebrated contemporaries, we can see the desire to imitate Goya and discern the original and romantic *duendecitos* [hobgoblins] that are scattered through his eighty *caprichos*.

Since an artist's productions are usually the most vivid reflections of his soul, it seems pointless to describe the moral qualities of our distinguished painter. Many numbers of this journal would be insufficient for the purpose. His many and devoted friends take pleasure in referring to his character and proving it to be original, frank, modest, brave and bold, especially in his most active years. If Goya had written his life, it would perhaps have afforded as much interest as that which the famous Benvenuto Cellini wrote of himself for the delight and instruction of artists and all lovers of the beautiful language of Boccaccio and Petrarch.[3]

[3. V. Carderera, 'Biografía de D. Francisco Goya, pintor', *El Artista*, II, 1835, pp. 253–5; reprinted in E. Lafuente Ferrari, *Antecedentes, Coincidencias e Influencias del Arte de Goya*, 1947, pp. 302–5. The first of four articles on Goya by Carderera. The others were published in *Semanario Pintoresco*, 1838 (reprinted in Lafuente, pp. 305–8) and *Gazette des Beaux-Arts*, 1860 and 1863.]

Appendix II

1. Goya's report to the Academy of San Fernando on the study of art, 1792.

Your Excellency,

In fulfilment, for my part, of Your Excellency's command that each of us should expound what he holds to be advisable for the Study of the Arts, I declare: That Academies should not be exclusive or serve other than as an aid to those who wish freely to study in them. They should banish every [trace of the] servile subjection of the Infant School, mechanical rules, monthly prizes, financial aid and other pettinesses which debase and make effeminate an art as liberal and noble as Painting. Nor should time be allocated to the [formal] study of Geometry and Perspective with the object of overcoming difficulties in drawing. For drawing necessarily demands them in its own time of those who show disposition and talent. The more they advance in drawing the more easily do they acquire knowledge of the other Arts. This we know from the examples of those who have risen highest in this respect. I do not name them, since the fact is so well known. I shall give a proof to demonstrate with facts that there are no rules in Painting and that the tyranny which obliges everyone, as if they were slaves, to study in the same way or to follow the same method is a great impediment to the Young who practise this very difficult art, which comes closer to the Divine than any other, since it makes known what God has created. Even those who have gone furthest in the matter can give few rules about the deep play of understanding that is needed, or say how it came about that they were sometimes more successful in a work executed with less care than in one on which they had spent most time. What a profound and impenetrable mystery is locked up in the imitation of divine nature, without which there is nothing good, not only in Painting (which has no other function than the exact imitation [of nature]) but also in the other sciences!

Annibale Carracci gave new life to Painting which had languished since the time of Raphael. Through the liberality of his genius he produced more and better pupils than all the other Professors, for he allowed each one to proceed as the spirit moved him, without obliging anyone to follow his style or method and making only those corrections which are directed towards achieving the imitation of truth. This can be seen in the different styles of Guido [Reni], Guercino, Andrea Sacchi, Lanfranco, Albano, etc. I cannot omit another clearer example. Those most able Painters we have known, who have taken the greatest pains to teach the method (as they have given us to understand) of their outworn style, how many pupils have they produced? Where are progress, rules, method? Have they achieved by their writings anything more than arousing the interest of those who are not and could never be Artists so as to exalt their own works and providing them with full licence to decide – in the very presence of those who understand this sacred Science, which demands so much study (even of those who were born to it) – to understand and discern what is best?

It is impossible for me to express the pain it gives me to see the flow of the dissolute or eloquent pen which so attracts the non-professor and is so feeble as not thoroughly to know the subject that it treats. What scandal it is to hear nature despised in favour of Greek statues by those who know neither one nor the other and are not conscious of

how the smallest part of nature overwhelms and amazes those who know most. What statue or pattern of one is there which is not copied from Divine nature? However excellent the Artist who made the copy, can he fail to proclaim that, when it is compared with Nature, one is the work of God and the other of our miserable hands? Will not anyone who attempts to set aside and improve Nature, rather than seek what is best in her, fall into a reprehensible and monotonous manner of painting like plaster casts, which is what has happened to all who have conscientiously followed this course [i.e. of not observing nature]. I seem to be drifting from my first purpose, but nothing is more necessary – if any remedy for the present decline of the Arts is possible – than that they must not be subject to the knowledge and authority of the other sciences but should be governed by their own merit, as has always been the case when great talents have flourished. Then the deluded tyrants [of taste] disappear and discerning connoisseurs are born who appreciate, venerate and encourage those who excel, providing them with work by which they can further improve their talent and using all their efforts to help them fulfil their promise in every way. This is true protection of the Arts and it has always been proved that it is their works that have made great men great. Finally, Sir, I can find no more effective means of advancing the Arts, nor do I believe that there is one, than rewarding and protecting those who excel [in them], holding the true Artist in esteem, giving free rein to the talent of Pupils who are inclined to study without confinement and without imposing measures to divert their natural inclinations towards one or another style of painting.

I have given my opinion in fulfilment of Your Excellency's request. If my hand does not govern my pen as I would wish it to, so as to make myself understood, I hope that Your Excellency will pardon it [i.e. my hand], for I have kept it busy all my life in the hope of reaping the advantage with which I have been dealing.

Madrid, 14 October 1792. Fran.co de Goya.[4]

2. Goya's report to Pedro Cevallos (Protector of the Academy of San Fernando), on the restoration of paintings, 1801.

Your Excellency: I hereby fulfil the royal command which Your Excellency was pleased to communicate to me, dated 30 December last, to the effect that I should advise you about the pictures which are in the charge of don Angel Gómez Marañón, that I should inspect those which he has transferred to new canvases, and those which he has cleaned [lit. washed] and freshened, and that I should give account of the improvement or damage that paintings can suffer through this treatment. After examining the method [of preparation] and the quality of the ingredients which he uses for his glaze, I must advise Your Excellency that I presented myself immediately in the Buen Retiro, [where] I inspected and examined with the greatest attention the work of that artist and the state of the pictures. Amongst these I was first shown the picture of Seneca, which he had on hand for cleaning and had already half completed the glazing and varnishing [lustre y bruñido].

I cannot exaggerate to Your Excellency the discordant effect produced by a comparison of those parts that had been retouched with those that had not. For the vigour and brio of the brush strokes and the mastery of the delicate and accomplished touches of the original which are preserved in the unrestored parts had disappeared and been

[4. Jutta Held, 'Goyas Akademiekritik', *Münchner Jahrbuch der Bildenden Kunst*, 1966, p. 214 f.]

totally destroyed in the restored. My feelings were stirred and my natural frankness did not allow me to hide from him how bad it seemed to me. I was subsequently shown others, all equally damaged and spoilt for the eyes of professionals and of really intelligent people. For not only is it certain that the more paintings are handled under the pretext of preserving them, the more they are destroyed. Even the artists themselves, if they came back to life now, could not retouch them perfectly because of the darkened tone of colours which is produced by Time, who is also a painter, according both to the maxim and observation of the wise. It is not easy [even for the artist himself] to preserve the rapid and transitory intent of the fancy and the harmony and order planned at the first execution in such a way that they are not weakened by change and retouching. And if this is thought to be inevitable for a consummate artist, what is to happen when retouching is undertaken by one who lacks the solid principles [of his art]?

With regard to the nature of the ingredients employed for the glazing [*lustre*] of the paintings, although I asked what he used, he spoke only of white of egg, without further explanation; so that I knew for certain that he was making a mystery of it and was anxious to hide the truth. But I know that the matter is not worth examination and like everything that smells of secrecy it is not worth much.

Such is the report which briefly and simply, subject always to the opinion of more learned and knowledgeable men, I put forward for the consideration of Your Excellency, taking this opportunity to offer my respects.

May Our Lord keep Your Excellency many years,

Madrid, 2 January 1801. Francisco de Goya.[5]

[5. *Goya: Colección de cuadros y dibujos precedida de su biografía y de un epistolario*, pub. Calleja, 1924, p. 63.]

Plates

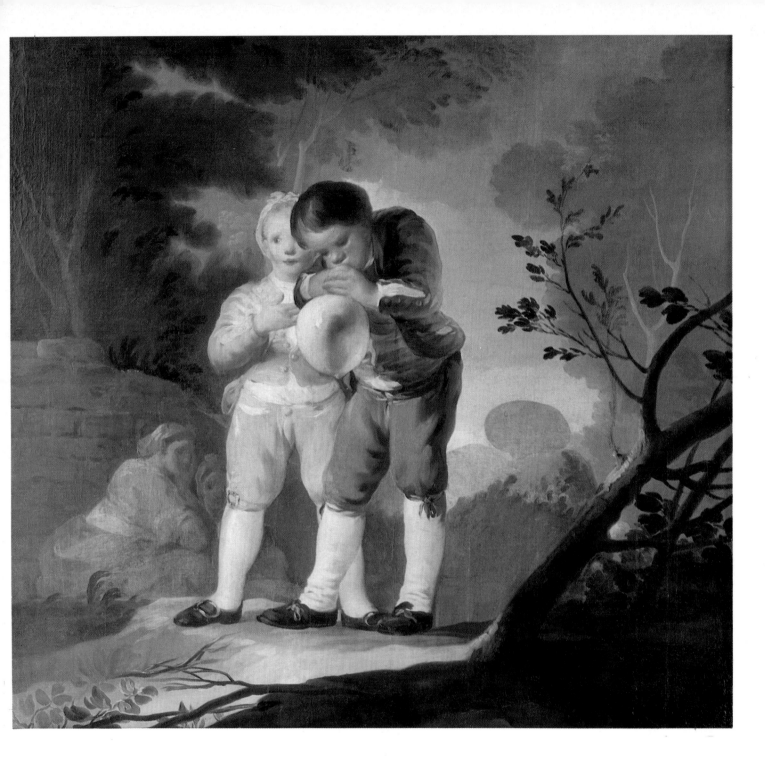

1. **Boys blowing up a Balloon.** 1777-1778. Madrid, Prado

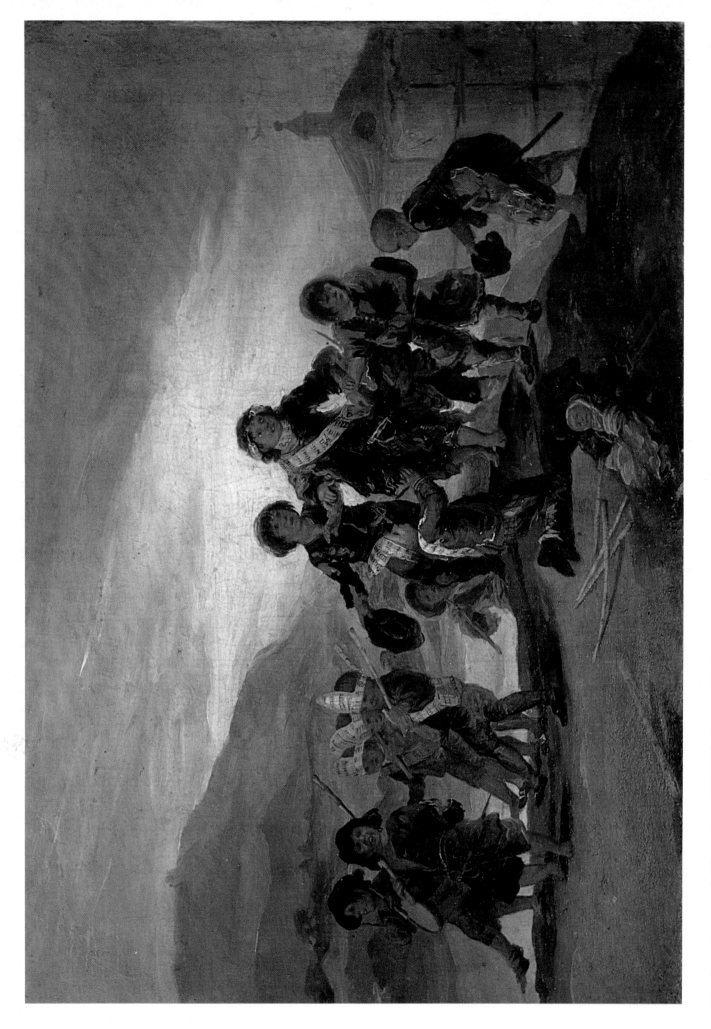

2. **Boys playing at Soldiers.** About 1776-1786. Glasgow, Pollok House, Stirling-Maxwell Collection

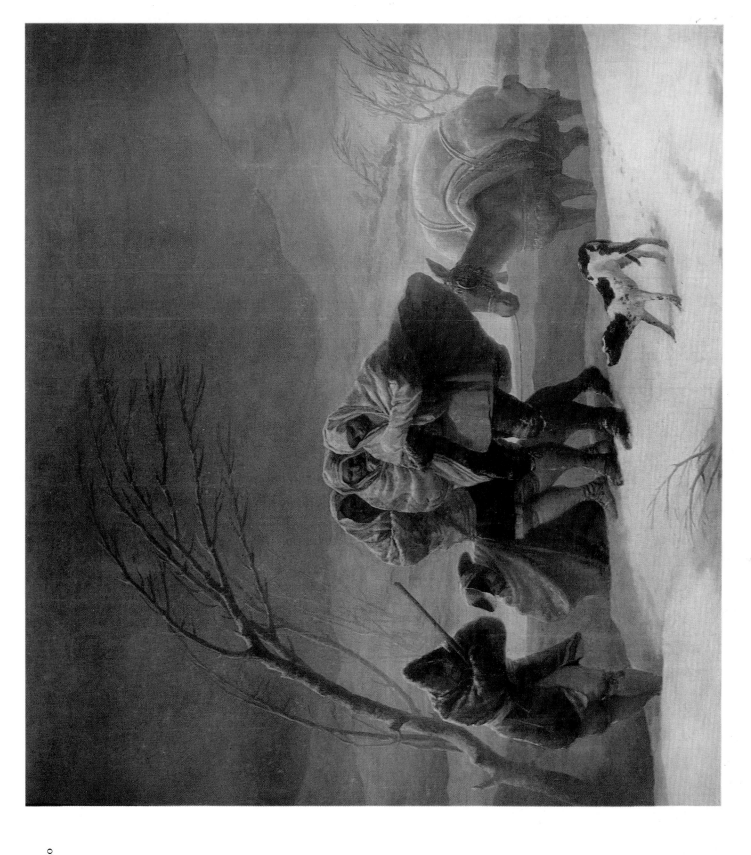

3. **The Snowstorm.**

1786-1787. Madrid, Prado

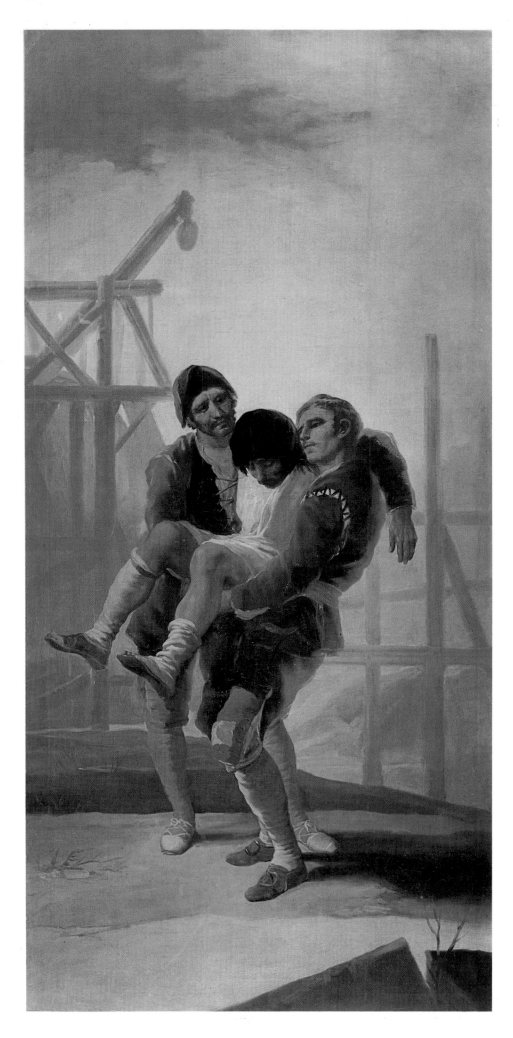

4. **The Injured Mason.** 1786-1787. Madrid, Prado

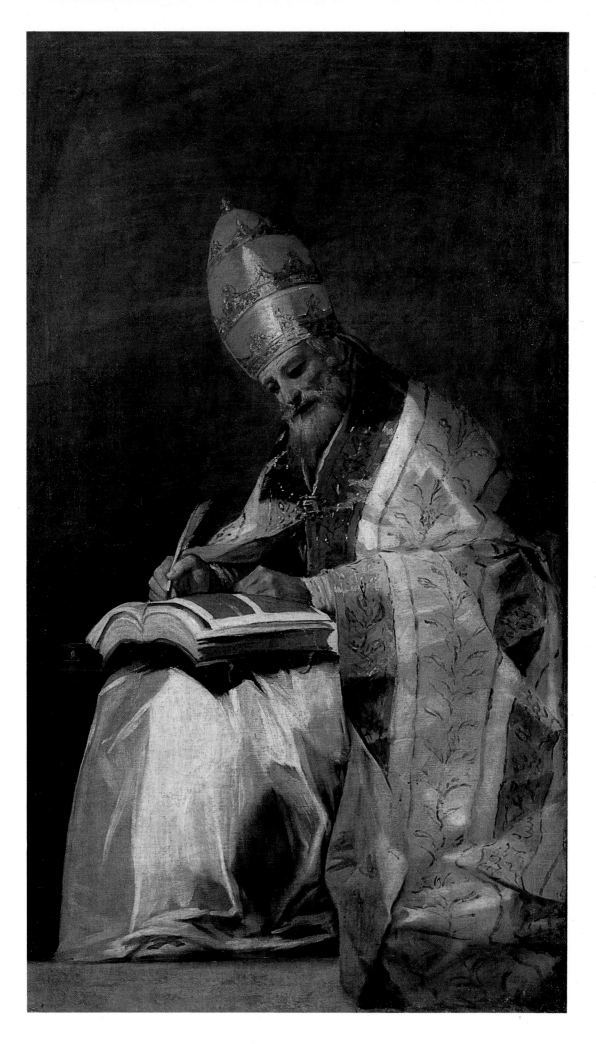

5. **St. Gregory.** About 1797. Madrid, Museo Romántico

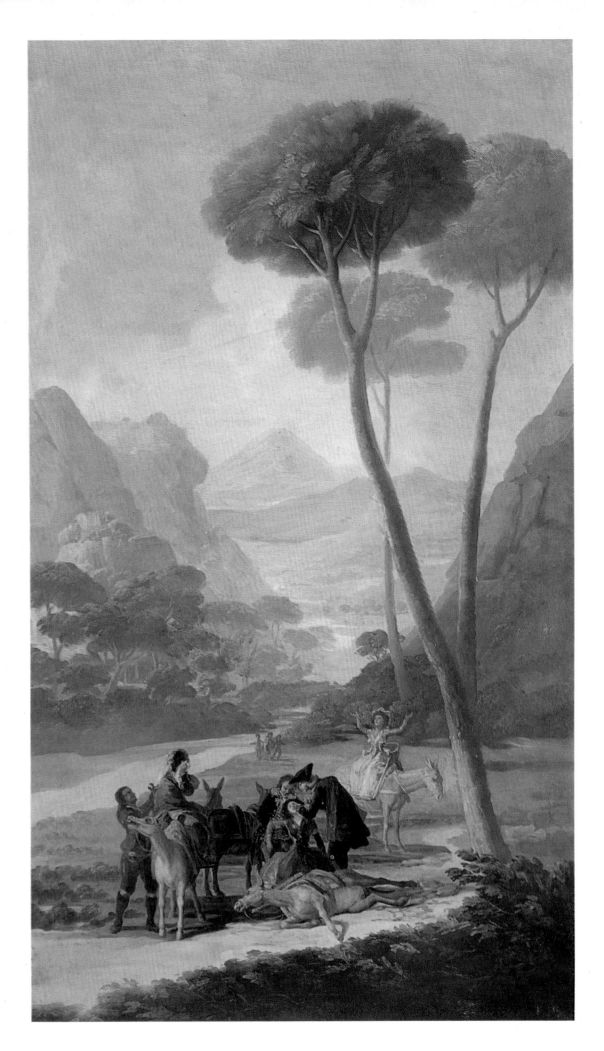

6. **La Caída (The Fall).** 1786-1787. Madrid, Duque de Montellano

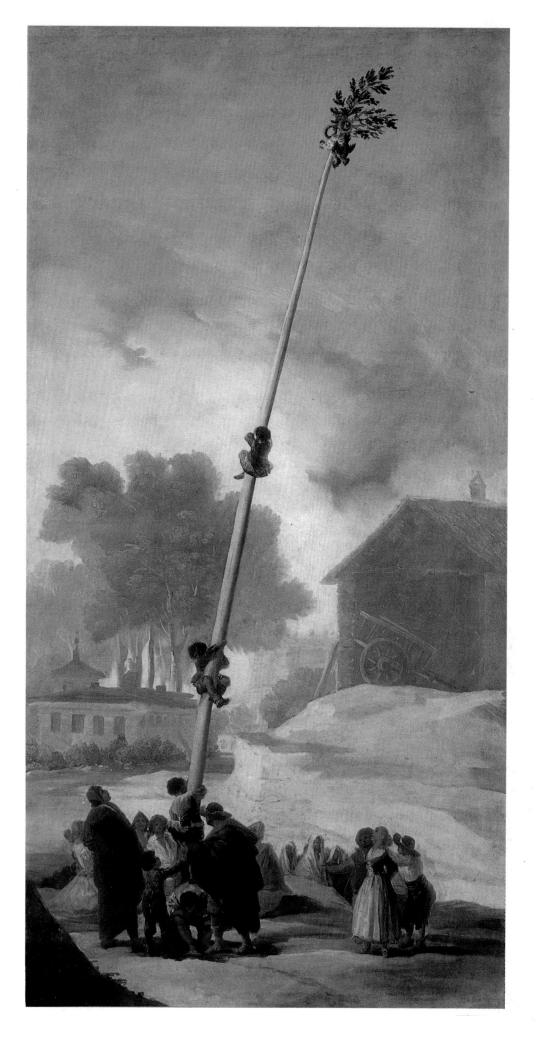

7. **La Cucaña (The Greasy Pole).** 1786-1787. Madrid, Duque de Montellano

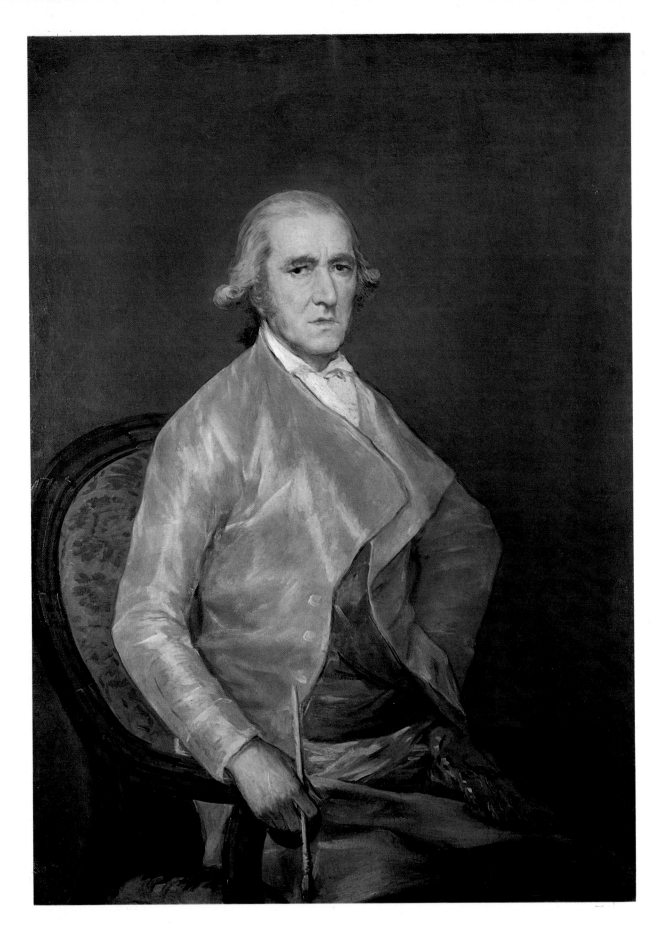

8. **Portrait of Francisco Bayeu.** About 1795. Madrid, Prado

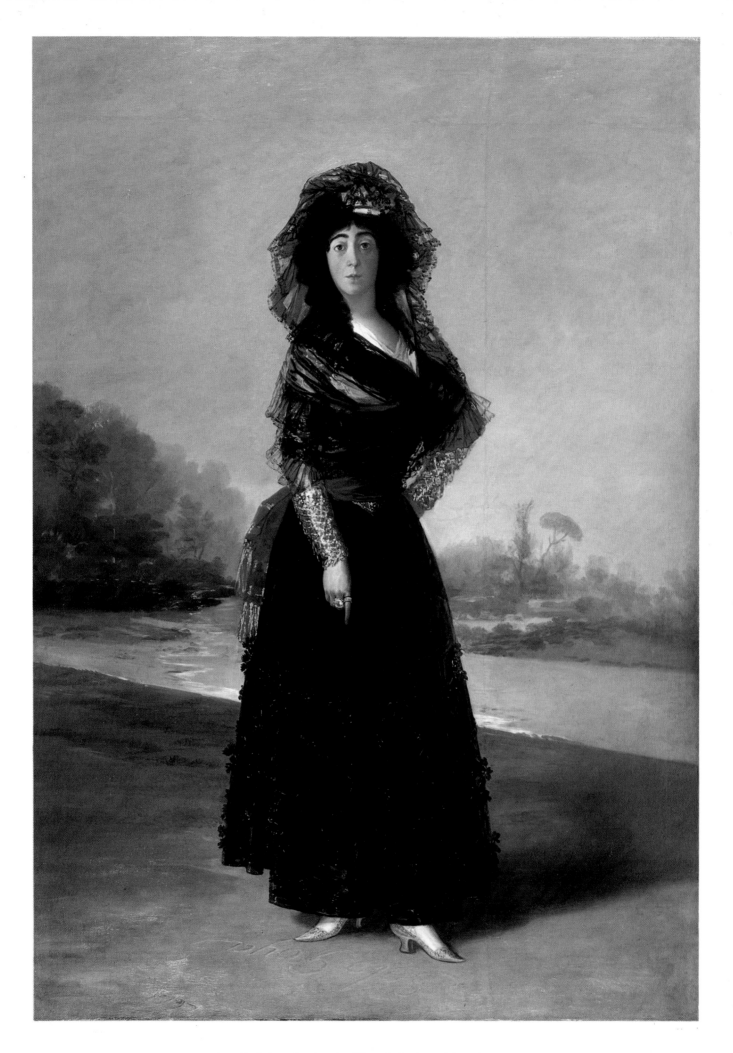

9. **Portrait of the Duchess of Alba.** 1797. New York, The Hispanic Society of America

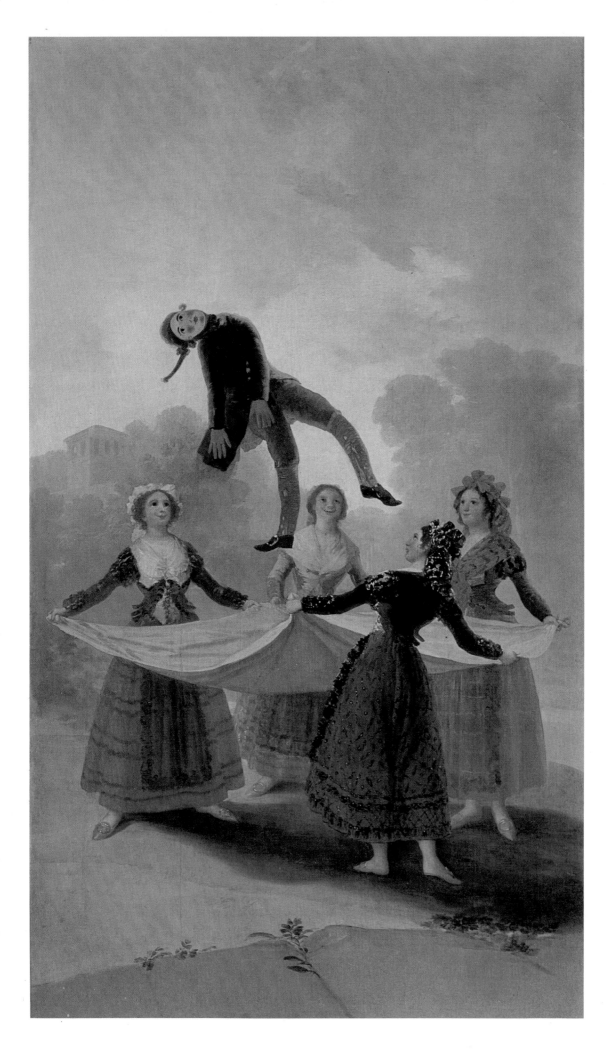

10. **El Pelele (The Straw Manikin).** 1791-1792. Madrid, Prado

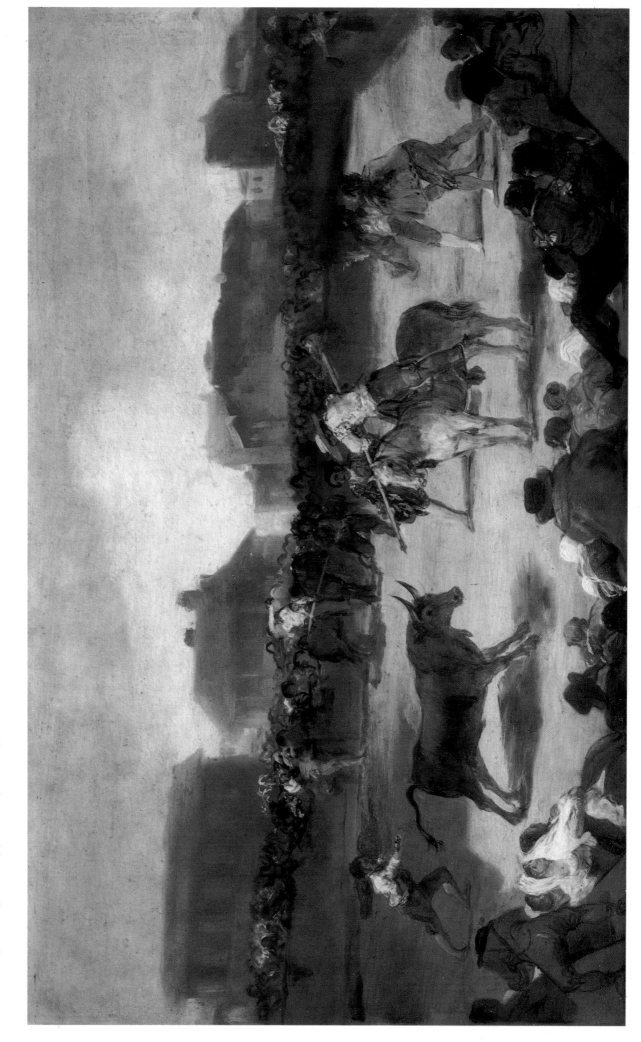

13. **A Village Bullfight.** 1793(?). Madrid, Academy of San Fernando

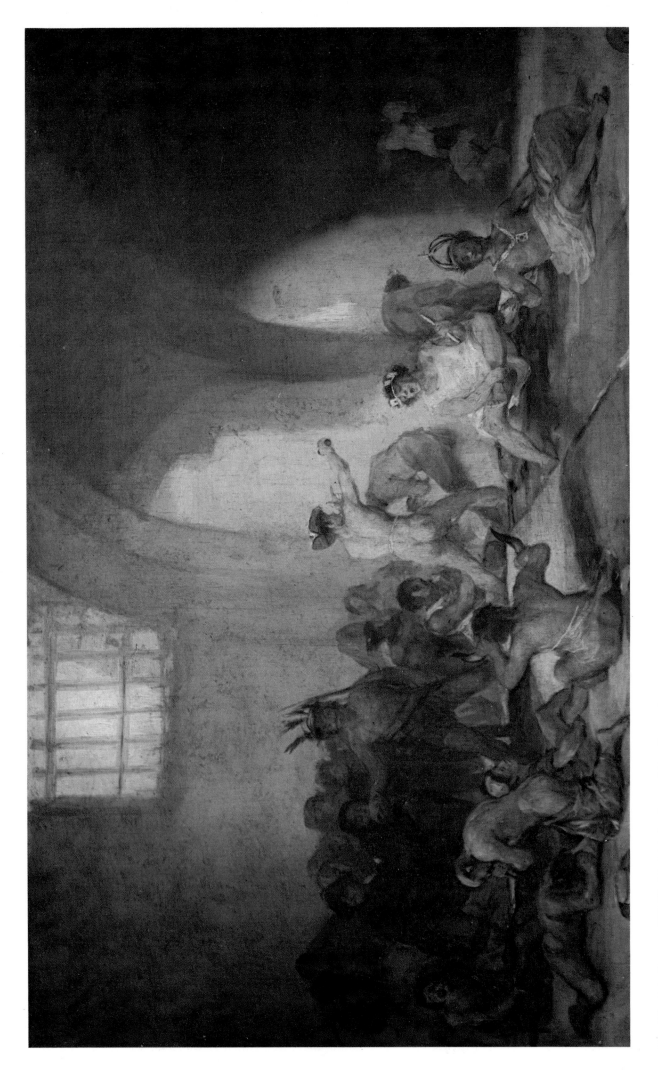

14. **The Madhouse.** 1793(?). Madrid, Academy of San Fernando

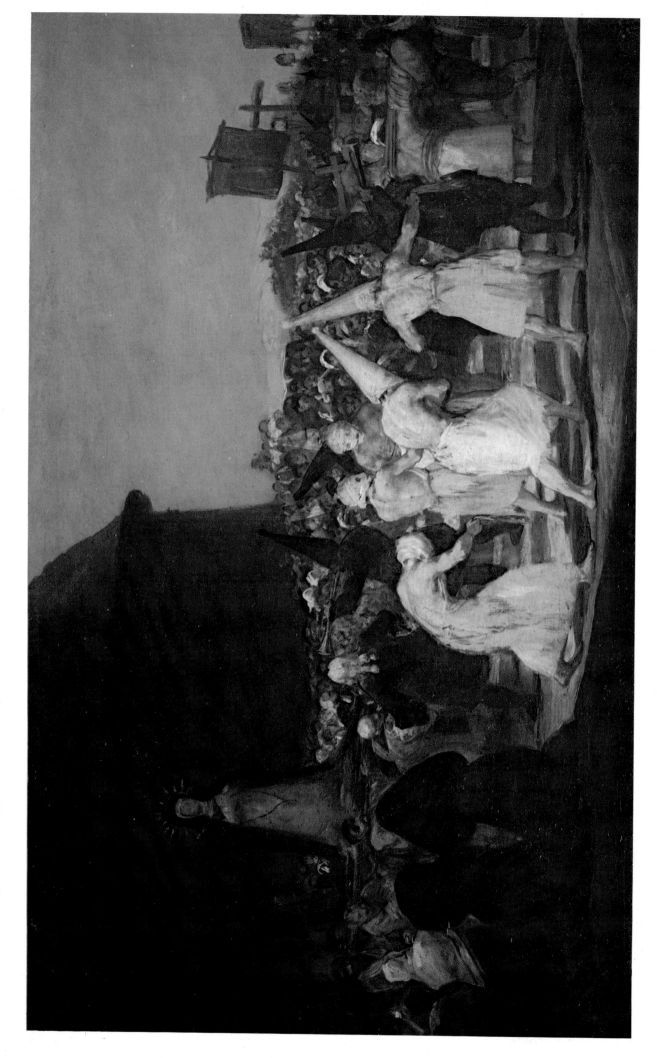

15. **A Procession of Flagellants.** 1793(?). Madrid, Academy of San Fernando

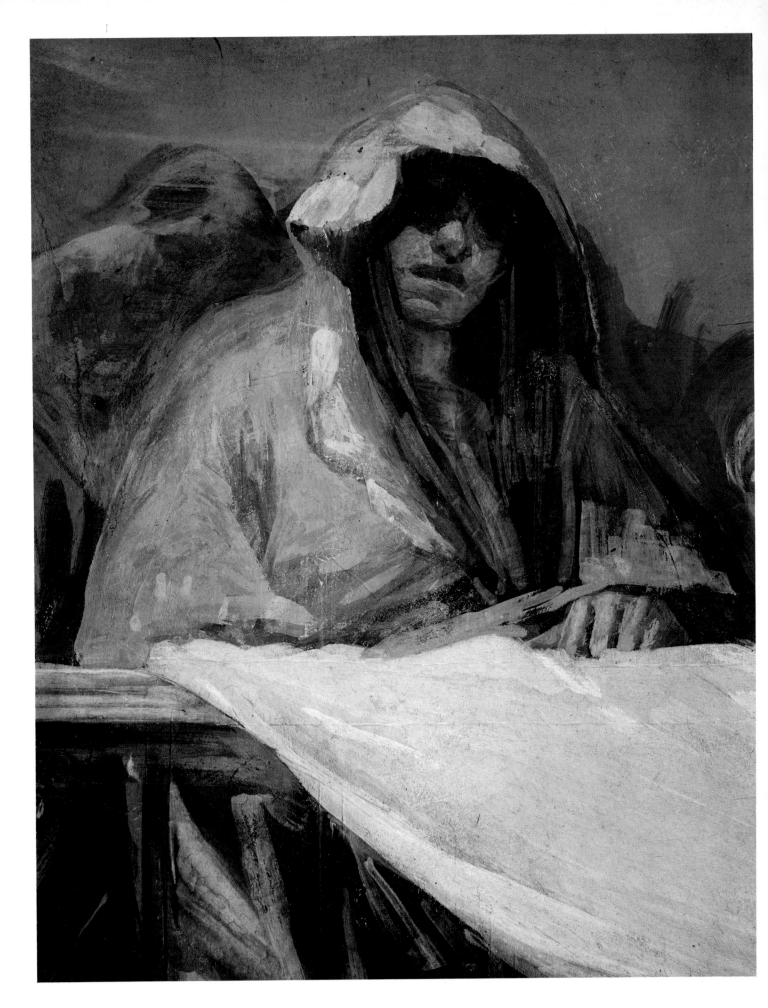

16. **Detail of the Crowd witnessing the Miracle of St. Anthony.** 1798. Madrid, San Antonio de la Florida

17. **Queen María Luisa** (detail of the group portrait reproduced in the text)

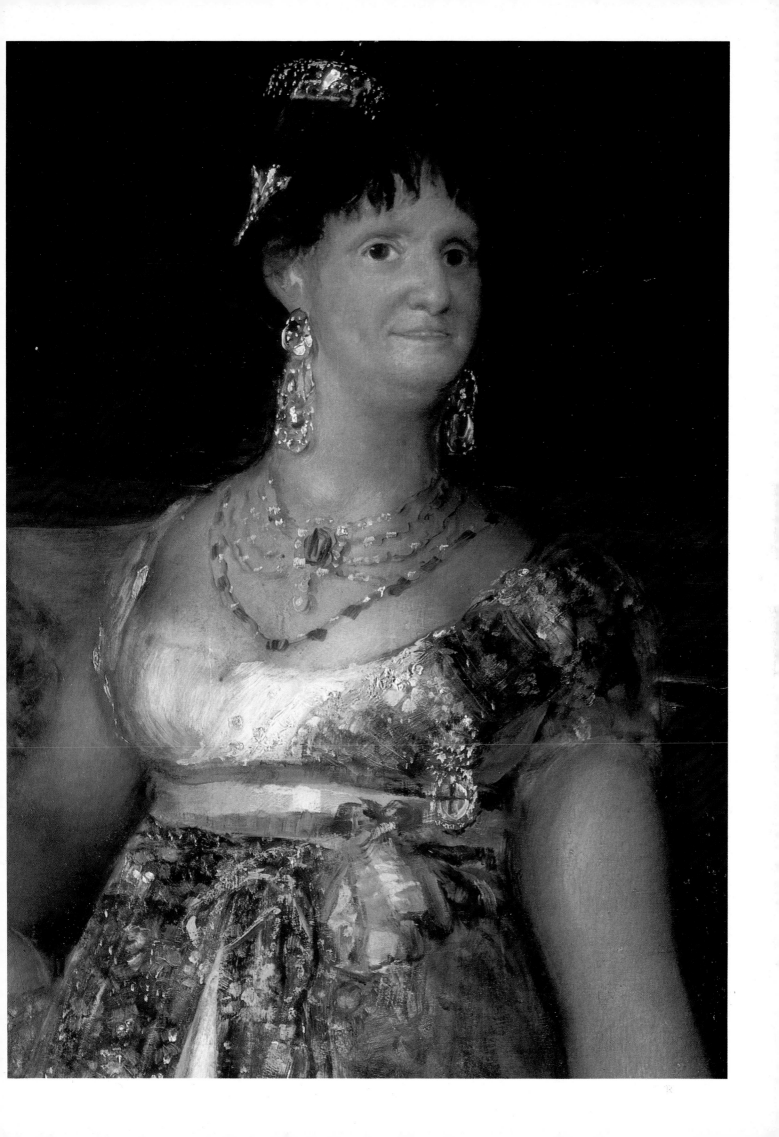

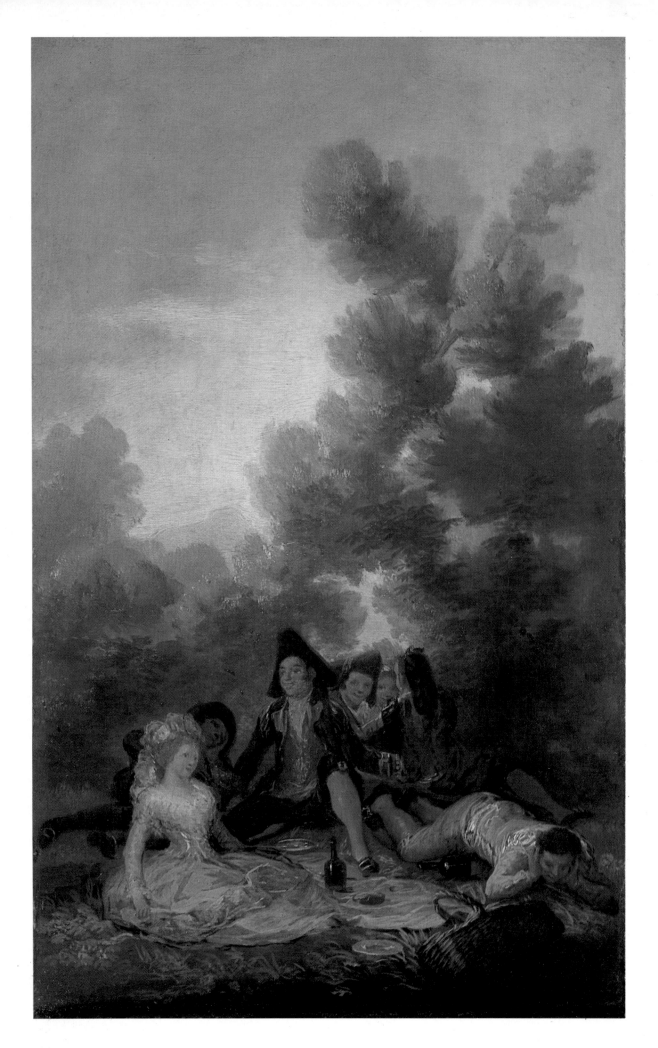

18. **A Picnic.** 1788(?). London, National Gallery

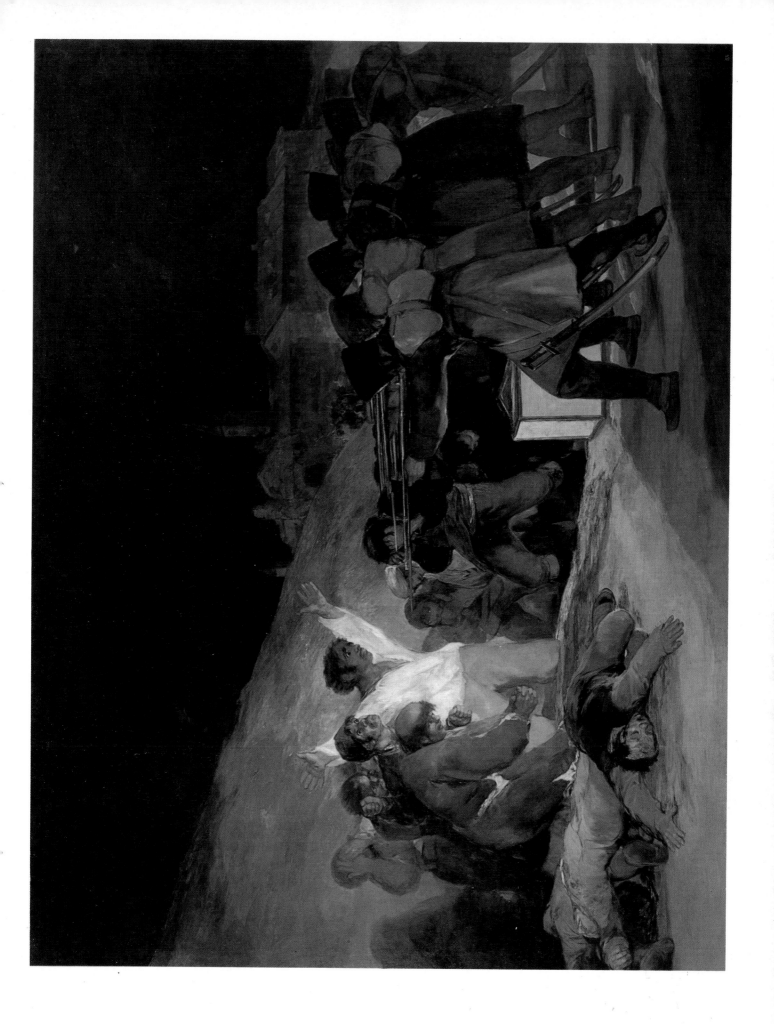

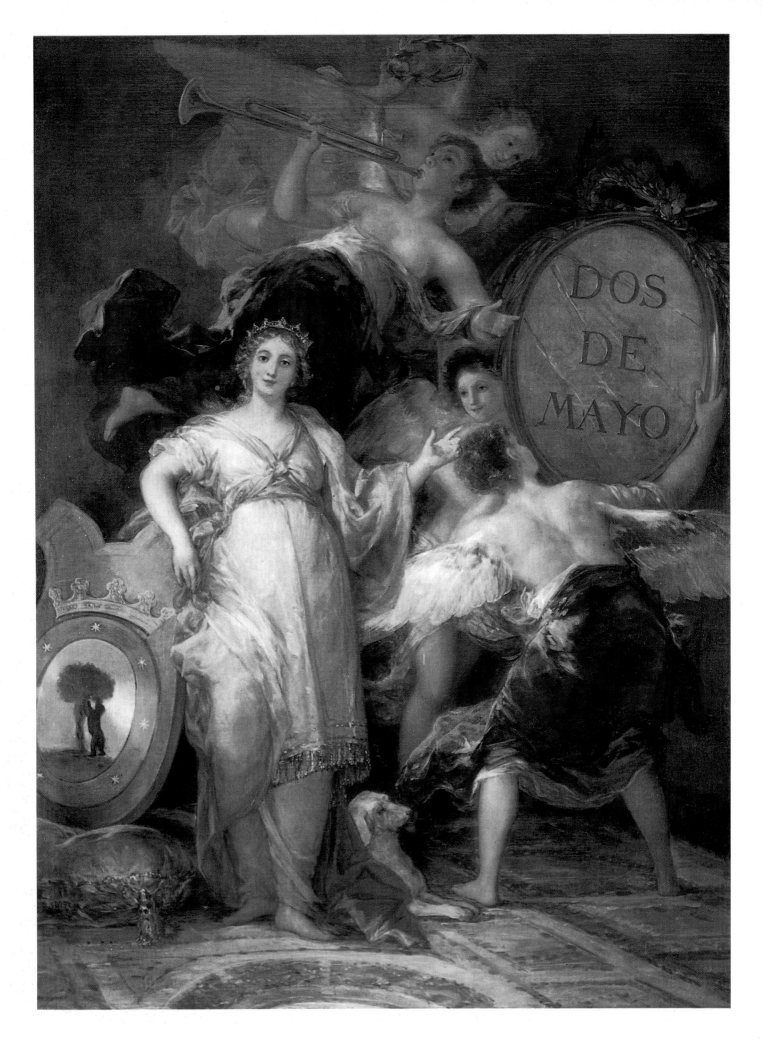

32. **Allegory of the City of Madrid.** 1810. Madrid, Ayuntamiento

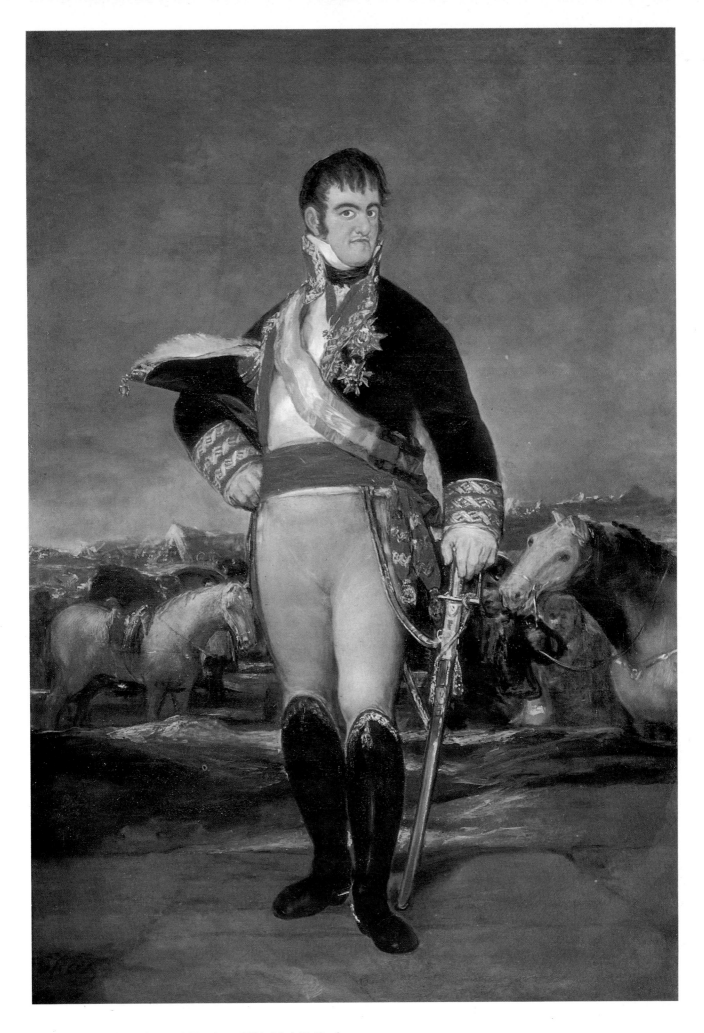

33. **Portrait of Ferdinand VII.** About 1814. Madrid, Prado

34. **Detail of Plate 31**

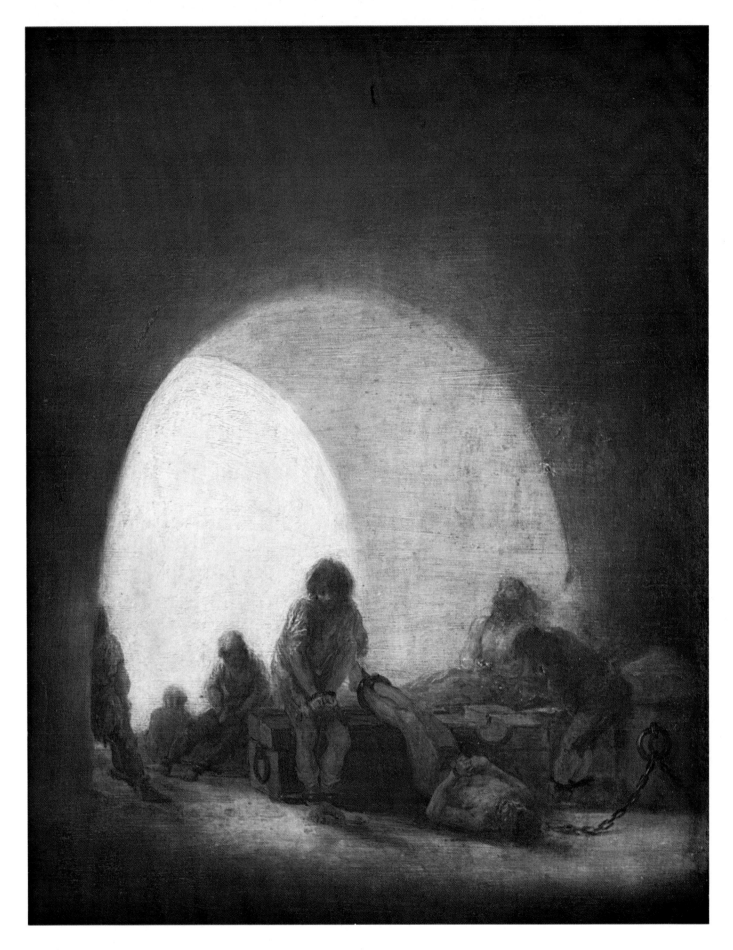

35. **A Prison Scene.** About 1810-1814. Barnard Castle, County Durham, Bowes Museum

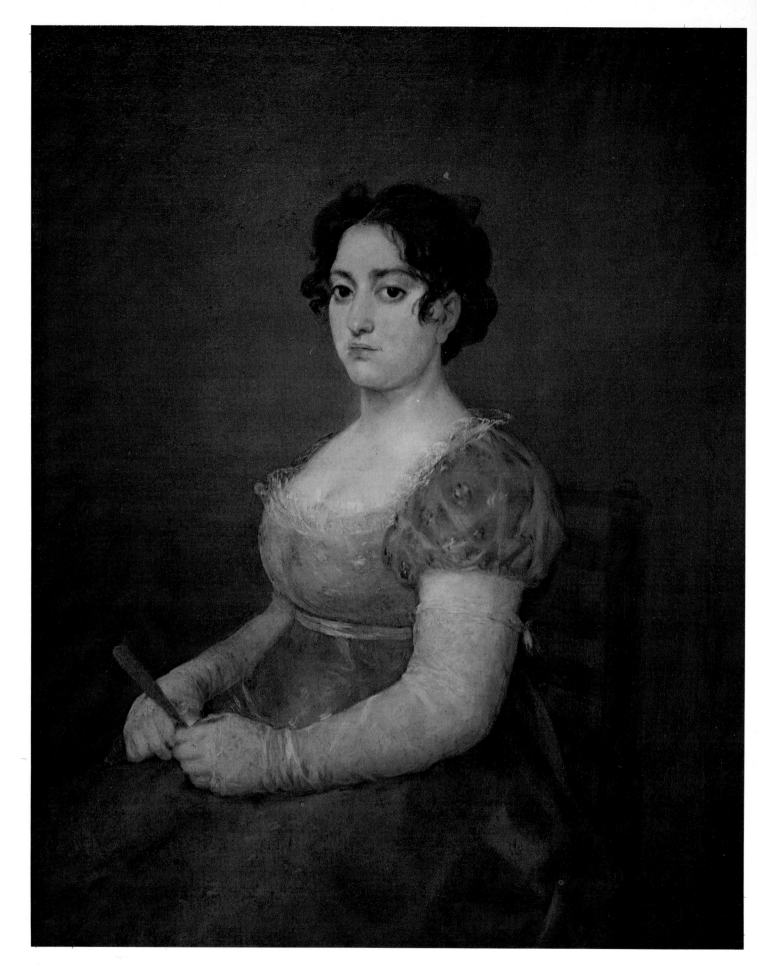

36. **Portrait of a Lady with a Fan.** About 1806-1807. Paris, Louvre

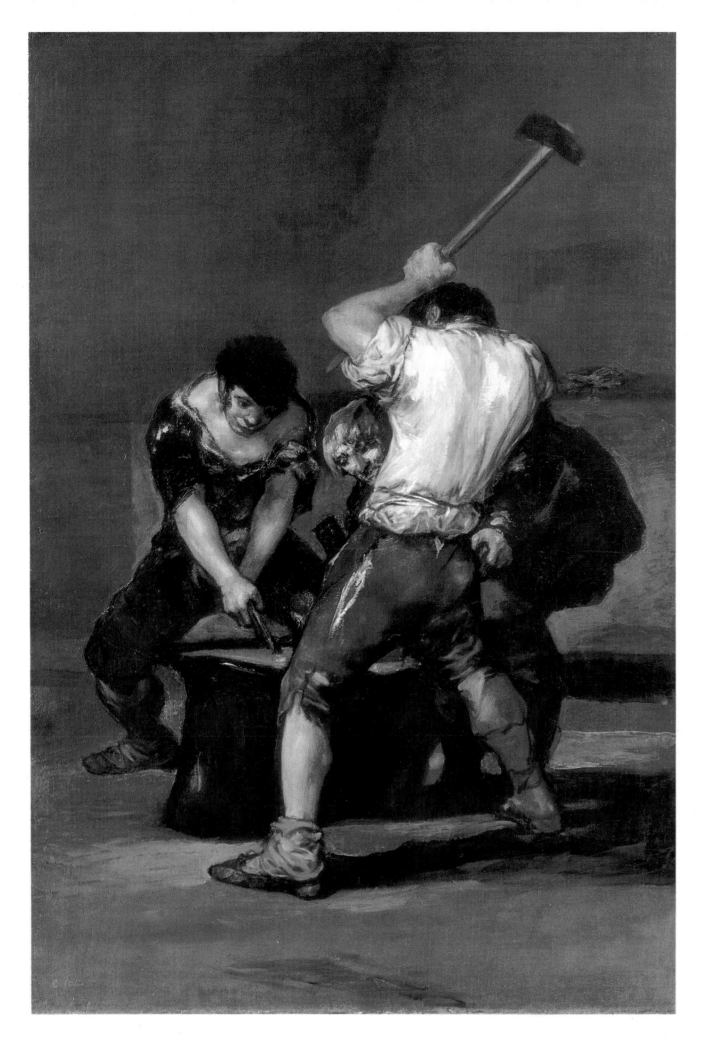

39. **The Forge.** About 1819. New York, The Frick Collection

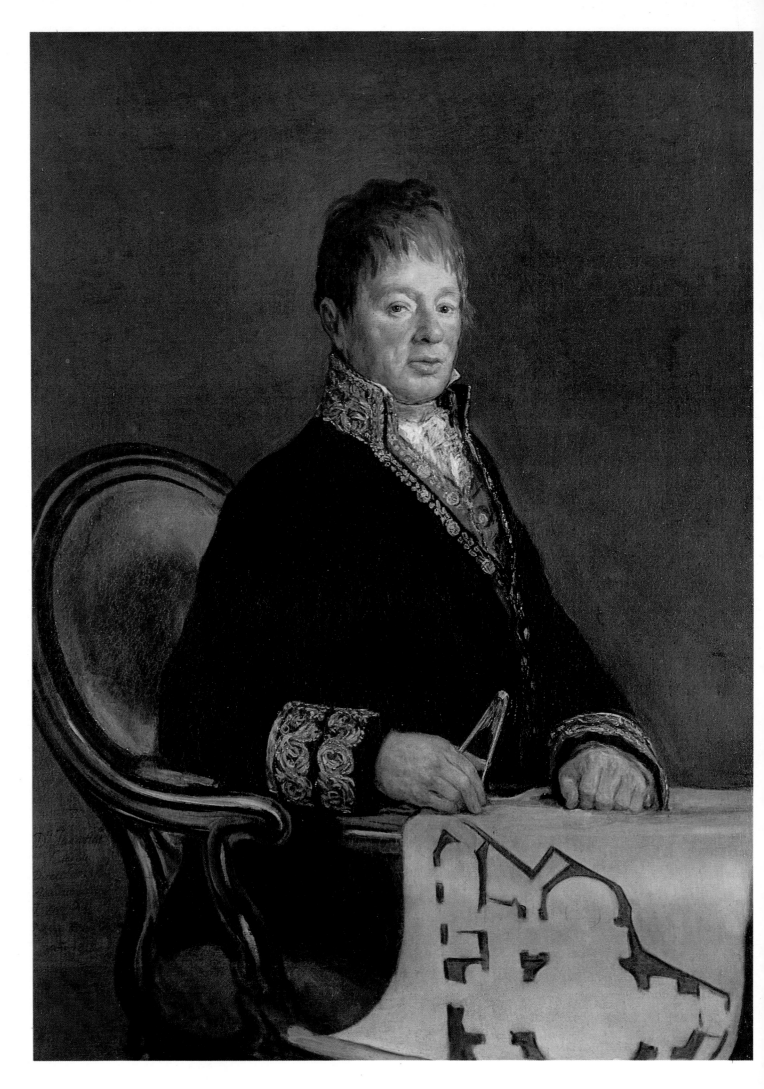

40. **Portrait of Juan Antonio Cuervo.** 1819. Cleveland, Museum of Art

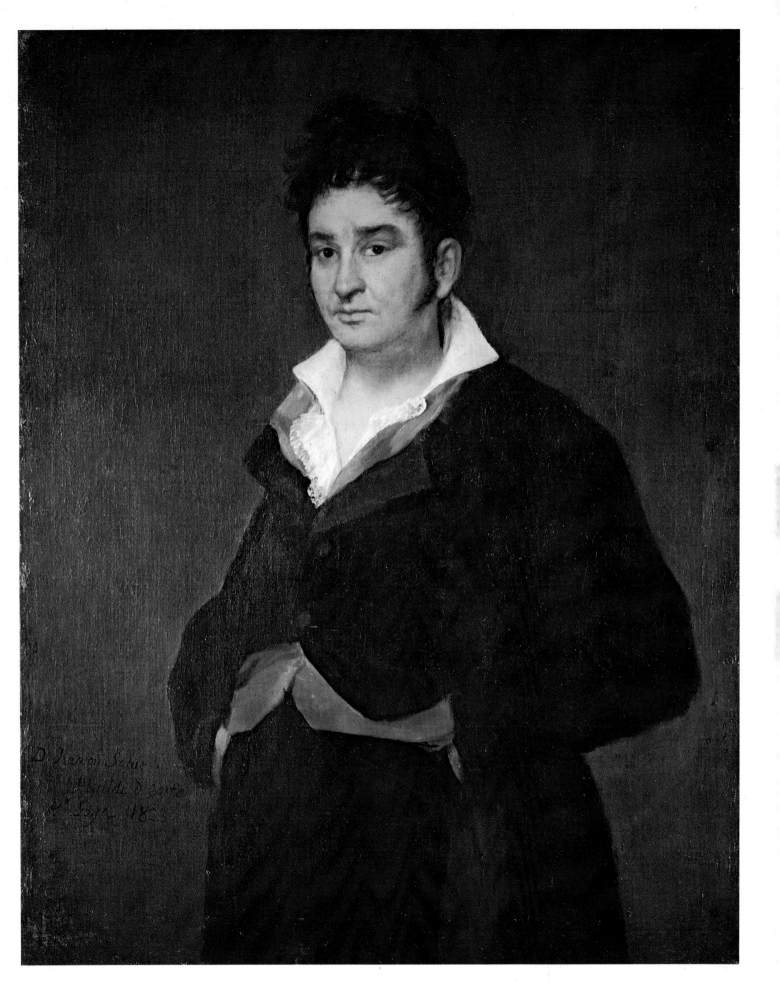

41. **Portrait of Ramón Satué**. 1823(?). Amsterdam, Rijksmuseum

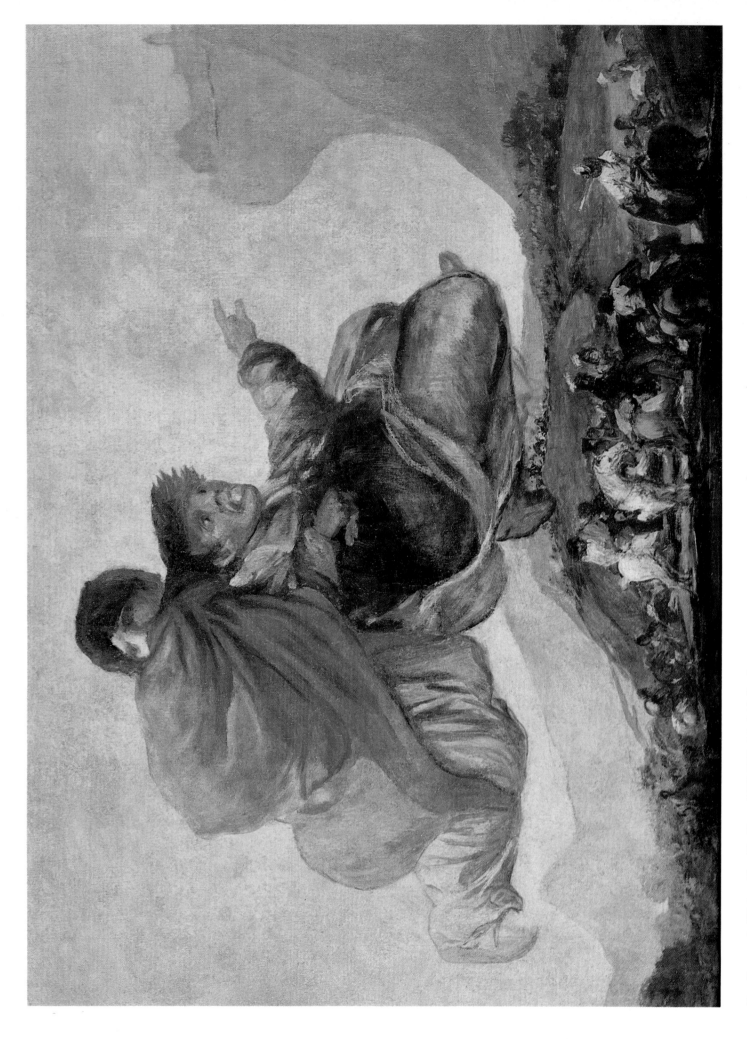

42. **Fantastic Vision** (detail). About 1820-1823. Madrid, Prado

Notes on the plates

Chronology

1746 30 March. Born at Fuendetodos, Aragon

1760–1764 (about). Studies under José Luzán in Saragossa

1763 and 1766 Competes unsuccessfully for scholarships offered by the Royal Academy of San Fernando, Madrid

1771 April In Rome; submits a painting to a competition held by the Academy in Parma

1771 Winter Submits sketches for frescoes in the Cathedral of El Pilar, Saragossa

1773 Marries Josefa Bayeu

1774 Summoned by Mengs to paint cartoons for tapestries to be woven at the Royal Factory of Santa Barbara, Madrid

1775–1792 Occupied intermittently with tapestry cartoons

1778 Publishes eleven etchings after paintings by Velázquez

1780 Elected to membership of the Royal Academy of San Fernando

1785 Appointed Deputy Director of Painting in the Academy

1786 Appointed Painter to the King (*Pintor del Rey*)

1789 Raised to the rank of Court Painter (*Pintor de Cámara*)

1792 Falls seriously ill during a journey to Andalusia and is left permanently deaf

1793 Paints group of uncommissioned cabinet pictures during convalescence

1795 Appointed Director of Painting in the Academy

1797 Resigns Directorship for reasons of health

1798 Fresco decorations in San Antonio de la Florida, Madrid

1799 February Announcement of the publication of the *Caprichos*

October Appointed First Court Painter (*Primer Pintor de Cámara*)

1800 Portrait of *Charles IV and his Family*

1803 Presents plates of the *Caprichos* to the King

1804 Applies unsuccessfully to be made Director-General of the Academy

1808 Napoleonic invasion of Spain. Goya paints an equestrian portrait of Ferdinand VII; swears allegiance to the French King, Joseph Bonaparte

1810 Dates some of the drawings for the *Desastres de la Guerra*

1811 Awarded the Royal Order of Spain by Joseph Bonaparte

1812 Paints an equestrian portrait of the Duke of Wellington

1814 The French expelled from Spain; restoration of Ferdinand VII; Goya paints the *2nd* and *3rd of May* to commemorate the War of Independence

1815 Summoned to appear before the Inquisition on account of the *Majas*

1816 Publication of the *Tauromaquia*

1819 Suffers serious illness; paints the *Last Communion of St. Joseph of Calasanz*

1820 Makes his last appearance at the Academy to swear allegiance to the newly restored Constitution

1820–1823 (about). Decorates his house, the *Quinta del Sordo*, with the 'Black Paintings'; etches the *Disparates* or *Proverbios*

1823 After a liberal interlude the King restored to absolute power

1824 Goya goes into hiding; applies for leave of absence to go to France; settles in Bordeaux

1826 Visits Madrid; resigns as First Court Painter

1828 16 April. Dies in Bordeaux

Frontispiece. SELF-PORTRAIT. Canvas, 46 × 35 cm. About 1815. Madrid, Prado.

Signed: *Fr Goy[a]/Aragones/Por el mismo.*

This is one of the most strikingly intimate of the many self-portraits painted, drawn or engraved by Goya. Though similar in style and general appearance and undoubtedly close in date to the *Self-Portrait* in the Academy of San Fernando, Madrid (dated 1815), it is not a replica. There are slight variations in the pose and costume and the expression of the face suggests a more melancholy mood.

In the text.
CHARLES IV AND HIS FAMILY. Canvas, 280 × 336 cm. 1800. Madrid, Prado.

Goya clearly had in mind for this royal group the composition of Velázquez's *Meninas*, which he had copied in an engraving many years before. Like Velázquez, he has placed himself at an easel in the background, to one side of the canvas. But his is a more formal royal portrait than Velázquez's: the figures are grouped – almost crowded – together in front of the wall and there is no attempt to create an illusion of space. The eyes of Goya are directed towards the spectator as if he were looking at the whole scene in a mirror. The somewhat awkward arrangement of the figures suggests, however, that he composed the group in his studio from sketches made from life (see Pl. 21). Goya is known to have made four journeys to Aranjuez in 1800 to paint ten portraits of the royal family. Since there are twelve figures in the group it is likely that the woman seen in profile and the woman whose head is turned away – the only two whose identity is uncertain – were not present at the time.

Goya's magnificent royal assembly is dominated, not by Charles IV, but by the central figure of the Queen, María Luisa, whose ugly features are accentuated by her ornate costume and rich jewels (see Pl. 17). For some unknown reason this was the last occasion that Goya is known to have painted any member of this royal family, except for the future Ferdinand VII (see Pl. 33), who stands in the foreground on the left. The unusual figure composition on the wall behind the group has not been identified.

1. BOYS BLOWING UP A BALLOON. Canvas, 116 × 124 cm. 1777–1778. Madrid, Prado.

One of four cartoons for tapestries to decorate the dining room of the Prince of Asturias in the Palace of El Pardo, delivered to the Royal Tapestry Factory on 24 January 1778. The others represent *Boys picking fruit*, the *Kite* and *Card-players*. These form part of the second series of cartoons painted by Goya which introduce a new range of subjects illustrating popular pastimes. The earlier series was devoted to scenes of hunting, fishing and shooting.

2. BOYS PLAYING AT SOLDIERS. Canvas, 29 × 42 cm. About 1776–1786. Glasgow, Pollok House, Stirling-Maxwell Collection.

One of a set of four paintings bought in Seville in 1842 by William Stirling, later Sir William Stirling-Maxwell,

Bt., author of the *Annals of the Artists of Spain* published in 1848. The paintings described in the *Annals* as 'hasty sketches of children at play' were amongst his early purchases; later he acquired two of Goya's miniatures painted in Bordeaux and a collection of his etchings which was of major importance. Stirling-Maxwell was one of the first English collectors of Goya and his account of the artist in the *Annals* was for many years the fullest that existed in English. Several versions of this early series exist: they seem to have been popular in Goya's time.

3. THE SNOWSTORM. Canvas, 275 × 293 cm. 1786–7. Madrid, Prado.

This was one of a series of tapestry cartoons (see also Pl. 4), painted shortly after Goya's appointment as Painter to the King (*Pintor del Rey*) in 1786. The sketches were submitted to the King at the Escorial in the Autumn of that year. The sketch for the *Snowstorm* was sold to the Duke of Osuna in 1799 as one of the *Four Seasons*. The cartoon and three others, painted at the same time for tapestries to decorate the dining room in the Palace of El Pardo, may have been intended as representations of the *Seasons*. If so, Goya's *Winter* is unconventional in portraying men enduring the rigours of a snowstorm rather than enjoying the pleasures or comforts of the season.

4. THE INJURED MASON. Canvas, 268 × 110 cm. 1786–7. Madrid, Prado.

This belongs to the same series of cartoons as the *Snowstorm* (Pl. 3) and was also the model for a tapestry that was to decorate the dining room in the Palace of El Pardo. The scene of an accident is even more unusual as palace decoration than the *Snowstorm* or *Poor Children at the Fountain*, another cartoon in the series.

The dramatic subject has been related (by Edith Helman) to an edict of Charles III, first published in 1778, concerning building construction and specifying how scaffolding should be erected 'to avoid accidents and death of workmen'. In the sketch for the cartoon (also in the Prado), purchased by the Duke of Osuna in 1799, the two men carrying the 'injured' mason have jovial expressions, which have given rise to its modern title the *Drunken Mason*.

5. ST. GREGORY. Canvas, 188 × 113 cm. About 1797. Madrid, Museo Romántico.

This belongs to a series of representations of the four Doctors of the Church, of which the *St. Augustine* and *St. Ambrose* are also extant. They are not documented but are reasonably assumed on stylistic grounds to have been painted after Goya's visit to Andalusia in 1797, because of their resemblance to Murillo's seated figures of *St. Isidore* and *St. Leander* in Seville Cathedral. In style and colour they also reflect Goya's earlier studies of Tiepolo.

6. LA CAÍDA (The fall). Canvas. 169 × 100 cm. 1786–7. Madrid, Duque de Montellano.

La Caída and *La Cucaña* (Pl. 7) belong to a series of seven

paintings of 'country subjects' made to decorate the large gallery in the Duchess of Osuna's apartment in the Alameda Palace, the Osuna country residence outside Madrid – known as *El Capricho*. The paintings were delivered on 22 April 1787. *La Caída* is described in Goya's account for the paintings submitted on 12 May 1787: 'an excursion in hilly country, with a woman in a faint after a fall from an ass; she is assisted by an abbé and another man who support her in their arms; two other women mounted on asses [and] expressing emotion and another figure of a servant form the main group and others who had fallen behind are seen in the distance, and a landscape to correspond.'

Though on a smaller scale, this series of decorative paintings is similar in style and character to the tapestry cartoons; but unlike the tapestry cartoons it includes some scenes, such as *La Caída*, which appear to represent actual occurrences. It has been suggested that the fainting woman in *La Caída* is the Duchess of Osuna, that the figure supporting her is Goya and that the weeping, mounted woman is the Duchess of Alba.

7. LA CUCAÑA (The greasy pole). Canvas, 169 × 88 cm. 1786–7. Madrid, Duque de Montellano.

Painted at the same time as *La Caída* (Pl. 6), *La Cucaña* is described in Goya's account: 'a maypole, as in a village square, with boys climbing up it to win a prize of chickens and *roscas* [ring-shaped biscuits] that are hanging on top, and several people watching, with a background to correspond.' The small scale of the figures in relation to the background is a feature of all the paintings of this series.

8. PORTRAIT OF FRANCISCO BAYEU. Canvas, 112 × 84 cm. About 1795. Madrid, Prado.

Goya's portrait of his brother-in-law and former teacher was probably painted after Bayeu's death in August 1795. It was unfinished when it was exhibited in the Academy of San Fernando later in the same month. Although this portrait is based on a self-portrait by Bayeu it has all the appearance of a study from life. The predominance of grey and silvery tones is characteristic of a group of Goya's portraits dating from the last years of the 18th century. An earlier portrait of Bayeu (1786) by Goya is in the Valencia Museum.

9. PORTRAIT OF THE DUCHESS OF ALBA. Canvas, 210 × 148 cm. 1797. New York, The Hispanic Society of America.

Signed: *Solo Goya/1797*; inscribed (on the rings): *Alba/Goya*.

The 13th Duchess of Alba was born in 1762, widowed in 1796 and died in 1802 in mysterious circumstances, which gave rise to the rumour that she was poisoned. She was a prominent figure in Madrid society; according to Lady Holland she was 'outstanding for her beauty, popularity, charm, riches and rank', and the poet Arjona acclaimed her as 'the new Venus of Spain'. Goya's relations with the Duchess were such that they have led to the suggestion

that she posed for the *Maja desnuda* (Pl. 22). He stayed with her at her Andalusian estate in Sanlúcar after her husband's death and made several drawings of scenes in the domestic life of the Duchess and her household. She is also recognizable in several plates of the *Caprichos* and in one unpublished etching, which seems to record an estrangement from the artist. In a letter to a friend (dated 1800), Goya describes a visit from the Duchess 'who came into my studio for me to paint her face and went out with it done for certainly I would rather do that than paint on canvas'.

The present portrait was almost certainly painted during Goya's stay at Sanlúcar and remained in his possession. The name *Alba* on the ring on the Duchess's third finger and *Goya* on that on the downward pointing index finger are in themselves evidence of Goya's intimacy with his sitter. The inscription on the ground at the Duchess's feet, to which her finger points, reads *Solo Goya*, the word *Solo* (only), recently uncovered, strengthening the assumption that they were lovers. The stiff figure with its expressionless face is, however, more like the puppet-like figures of the tapestry cartoons than a portrait of a familiar sitter.

10. EL PELELE (The straw manikin). Canvas, 267 × 160 cm. 1791–2. Madrid, Prado.

This belongs to Goya's last suite of tapestry cartoons, the only series made for Charles IV after Goya's appointment as *Pintor de Cámara*. The tapestries were to decorate one of the apartments in the Escorial and the subjects, chosen by the King, were to be 'rural and jocose'. Goya had delayed making the sketches as he objected to receiving his instructions from Maella instead of from the Lord Chamberlain. He eventually submitted, since he did not, he said, want to appear proud. After the naturalism of some of the earlier cartoons (e.g. Pls. 3 and 4), the stiffness of the figures and their artificial expressions come as a surprise. The human figures are as puppet-like as the straw manikin they are tossing in a blanket.

11. THE BURIAL OF THE SARDINE. Panel, 82 × 60 cm. 1793 (?). Madrid, Academy of San Fernando.

This painting, together with the *Bullfight* (Pl. 13), the *Madhouse* (Pl. 14), the *Procession of Flagellants* (Pl. 15) and a fifth, representing an Inquisition scene, entered the Academy in 1839 as the bequest of Manuel García de la Prada, who had been a patron of the artist. In his will, dated 17 January 1836, they are described as 'Five pictures on panel, four of them horizontal, representing an auto da fé of the Inquisition, a procession of flagellants, a madhouse, a bullfight; another which is larger represents a masked festival; all painted in oil by the celebrated Court Painter don Francisco de Goya, and much praised by the Professors'. The history of these five paintings before they entered García de la Prada's collection is not known but it is possible, even probable, that they were among the group of cabinet pictures that Goya made during his convalescence from the illness that left him deaf. They enabled him, he wrote to Bernardo de Iriarte,

Vice Protector of the Academy, in January 1794, to make 'observations for which there is normally no opportunity in commissioned works, which give no scope for fantasy and invention'. After they were shown to members of the Academy, who expressed their approval, Goya asked for them to be sent to the house of the Marqués de Villaverde, because he knew that 'the Señorita is so knowledgeable about drawing that she will be pleased to see them'. The masked festival represents the 'Burial of the Sardine', a popular Spanish festival marking the end of Carnival and beginning of Lent, which still takes place in some parts of the country. In a sketch for the painting (a drawing in the Prado), the banner is differently decorated and carries the inscription *Mortu[u]s*. The popular scene is brought to life in a bold sketchy style. The treescape in the background is similar to that of the cartoons but there is much more movement among the figures, and the fixed expressions on many of the faces in the cartoons are recalled by the masks worn by the principal actors.

12. BLIND MAN'S BUFF. Canvas, 269 × 350 cm. 1789. Madrid, Prado.

In 1788 Goya was engaged on sketches for cartoons for tapestries to decorate the bedroom of the Infantas in the Palace of El Pardo (see Pl. 18). Goya wrote to his friend Zapater on 31 May 1788 telling him that he had been ordered to complete the sketches 'in time for the Court's arrival. . . . I am working with great determination and vexation as there is little time and they have to be seen by the King, Princes, etc. . . . I can neither sleep nor rest until I have finished the job and don't call it living, this life that I live. . . .' The *Blind Man's Buff* is the only finished cartoon made from these sketches (the sketch for it is in the Prado), probably because of the death of Charles III and the subsequent withdrawal of tapestries from El Pardo. Goya has reverted to a conventional composition with marionette-like figures for the representation of a society pastime – a pastime described by Lady Holland in her *Spanish Journal* (1803) as one of 'the pleasures of the nursery offered to grown-up ladies and gentlemen'.

13. A VILLAGE BULLFIGHT. Panel, 45 × 72 cm. 1793 (?). Madrid, Academy of San Fernando.

The same history and putative dating as the *Burial of the Sardine* (Pl. 11). Although many of his contemporaries were opposed to bullfighting (Charles III imposed restrictions on the sport; it was banned in 1808 but the ban was lifted by Joseph Bonaparte in 1810), there is every reason to believe that Goya was an *aficionado*. There is even some truth in the stories of his performance in the ring. In a letter of 1823, his friend Moratín writes from Bordeaux: 'Goya says that he has fought bulls in his time and that with his sword in his hand he fears no-one.' Goya made portraits of several bullfighters and many paintings, drawings and engravings of the national sport. A scene of the baiting of young bulls (*La Novillada*) was the subject of one of his early tapestry cartoons and a rounding up of bulls (*El encierro de los toros*) was one of his decorations for the Osuna country residence. In 1816 he

published the *Tauromaquia*, a series of thirty-three etchings, for which he had made many drawings. Among his last works executed in France, is a set of four lithographs, the *Bulls of Bordeaux*. The *Village Bullfight* is one of his most impressive paintings of the subject. The sketchy style and dark tones create a vivid impression of the actions of the protagonists and the dense crowd of spectators grouped round the scene. It was perhaps in a setting such as this that Goya himself sometimes entered the ring as an amateur bullfighter.

14. THE MADHOUSE. Panel, 45 × 72 cm. 1793 (?). Madrid, Academy of San Fernando.

The same provenance and putative dating as the *Burial of the Sardine* (Pl. 11). In his letter of thanks to Bernardo de Iriarte for the kindness with which the members of the Academy had viewed the paintings that he had sent him, Goya says that he is working on another picture to complete the set. It represented a madhouse, a scene that he had witnessed in Saragossa. The painting that corresponds to his description is not the painting illustrated here but one now in the Meadows Museum, Southern Methodist University, Dallas. This does not, however, mean that both could not have belonged to the set of cabinet pictures in question. Though the two madhouse scenes are different in format and the Meadows Museum painting is on tin, not panel, they are so similar in style and in the manner of portraying the expressions of the madmen that they must be very close in date. Many drawings of lunatics, made late in Goya's career, are also extant and testify to his continued interest in the physiognomics of madness. The Academy *Madhouse* has been compared with Hogarth's scene in Bedlam in the *Rake's Progress* and some of his madmen, like Hogarth's, wear traditional attributes – a crown, a feathered headdress and tarot cards. But Goya's Bedlam is a much more horrifying sight, a place of darkness only partially lit, the postures, gestures and expressions of the inmates indicating their pitiful condition. The Academy painting is perhaps Goya's most dramatic and compassionate record of what he saw in the madhouse in Saragossa.

15. A PROCESSION OF FLAGELLANTS. Panel, 46 × 73 cm. 1793 (?). Madrid, Academy of San Fernando.

The same provenance and putative dating as the *Burial of the Sardine* (Pl. 11). The participation of flagellants in Holy Week processions in Spain was banned in 1777 but evidently not effectively since the ban was published again in 1779 and 1802. Goya's known hatred of fanaticism, explicit in many later drawings and engravings, suggests that his choice of subject was intended as an indictment of this form of public penance. So does his manner of recording the scene. The holy image of the Virgin is silhouetted against the dark wall of the church and the bloodstained figures of the flagellants stand out from and dominate the procession. An Inquisition scene in the same series is similar in character. Both paintings combine realistic reportage with critical intent in a manner, often seeming to approach caricature, which is peculiar to Goya.

16. DETAIL OF THE CROWD WITNESSING THE MIRACLE OF ST. ANTHONY. Detail of the decoration of the cupola of the church of San Antonio de la Florida, Madrid. Fresco. 1798.

The church of San Antonio, a small neo-classical building in a working-class district on the outskirts of Madrid, was a royal chapel completed in 1798. The only document referring to Goya's decorations is an account for materials 'for the work in the chapel of San Antonio de la Florida, which he carried out at His Majesty's bidding in this year, 1798'. The account, dated 20 December, covers the period between June and October and includes the cost of a carriage to take Goya to and from the church every day from 1 August until the completion of the work. The decoration of the cupola, apse, lunettes and pendentives, executed in fresco with added touches of tempera, is unprecedented in Goya's oeuvre for the boldness and individuality of its style. The placing of the principal scene of the miracle on the walls of the cupola – usually occupied by a representation of heaven – is unconventional, like the decoration of the walls below with female angels and painted curtains. The effect of the whole is almost that of a secular painting, strong in colour and free in handling. See also Pl. 20 and Fig. 1.

17. QUEEN MARÍA LUISA: DETAIL OF GROUP-PORTRAIT OF CHARLES IV AND HIS FAMILY (Plate in text).

18. A PICNIC. Canvas. 41.3×25.8 cm. 1788 (?). London, National Gallery.

This was probably one of the sketches which Goya made in 1788 for cartoons for tapestries to decorate the bedroom of the Infantas in the palace of El Pardo. Only one of the sketches was used, the *Blind Man's Buff* (Pl. 12), possibly on account of the death of Charles III and the subsequent withdrawal of the tapestries from the palace for which they were intended. This sketch is believed to have been one of two 'country subjects' acquired by the Duke of Osuna for the cabinet of the Duchess and paid for in 1799. It may give one of the first hints of the advent of Goya's later manner. It is, however, probably a sketch and not a finished painting, which may account for its apparently advanced technique.

19. THE BEWITCHED MAN. Canvas, 42.5×30.8 cm. About 1798. London, National Gallery.

The inscription: LAM/DESCO (*Lámpara descomunal;* 'extraordinary lamp') identifies the subject as a scene from *El hechizado por fuerza* ('The man bewitched by force'), a play by Antonio de Zamora. The protagonist is led to believe that he is bewitched and that his life depends on keeping a lamp alight. The walls are decorated with grotesque paintings to frighten him. Goya has turned a scene from a comedy into something much more frightening. The demon holding the lamp is his innovation. This is one of six pictures of 'witches' painted by Goya for the Alameda of the Duke and Duchess of Osuna and paid for in 1798. The subjects are similar to scenes of witchcraft in the *Caprichos* on which Goya was working at this time.

20. SEE PLATE 16.

21. PORTRAIT OF THE INFANTE DON FRANCISCO DE PAULA ANTONIO. Canvas, 74×60 cm. 1800. Madrid, Prado.

This is one of several surviving portrait sketches – rare in Goya's oeuvre – for the group of *Charles IV and his Family* (Plate in text). The sitter is the six-year-old Infante, whose hand the Queen holds in the finished painting. He is reputed to have been the son of the Prime Minister, Godoy. The sketch is doubtless one of the ten portraits painted at Aranjuez in 1800, presumably as studies for the group portrait. In transferring the sketches to the large canvas, Goya made some modifications. In the case of the young Prince, he made the head rounder and the expression more childish and less alert.

22. LA MAJA DESNUDA (The naked maja). Canvas, 97×190 cm. About 1800-1803. Madrid, Prado.

23. LA MAJA VESTIDA (The clothed maja). Canvas, 95×190 cm. About 1800–1803. Madrid, Prado.

Goya's *Majas* are two of his most famous and most discussed masterpieces. The identity of the model, their date and for whom they were painted are problems that are still unsolved. Their early history is unknown and even the date when they are first recorded is uncertain. Beruete quotes a description in an inventory of the collection of Godoy, made in 1803, of 'a naked Venus on a bed' and 'a clothed *maja*' by Goya. But no trace of this inventory has been found by later critics, who claim that the earliest reference to the paintings is in an inventory of Godoy's collection, dated 1 January 1808, where they are called 'gipsies'. In an article on the *Caprichos* published in Cadiz in 1811, Goya's *Venuses* are mentioned amongst his most admired works (they are also called Venuses in Goya's biography by his son). The next mention of the *Majas* is towards the end of 1814, when Goya was denounced to the Inquisition for being the author of two obscene paintings in the sequestrated collection of the Chief Minister Godoy, 'one representing a naked woman on a bed, ... and the other a woman dressed as a *maja* on a bed'. On 16 May 1815, the artist was summoned to appear before a Tribunal 'to identify them and to declare if they are his works, for what reason he painted them, by whom they were commissioned and what were his intentions'. Unfortunately Goya's declaration has not yet come to light.

Godoy's position at court and his known taste for paintings of female nudes (there were many others in his collection) makes it possible that the *Majas* were painted for him. An alternative suggestion is that they were in the Duchess of Alba's collection and acquired by Godoy after her death, together with Velázquez's 'Rokeby' *Venus* (London, National Gallery) and other pictures. Goya's relations with the Duchess of Alba have made her the most popular candidate as a model for the *Majas*, at least as a source of inspiration. The lack of resemblance in the heads of Goya's earlier portraits of her (Pl. 9) is usually explained by the need to conceal her identity. Whoever the model may have been and whoever the pictures were

made for, Goya's naked *Maja* is unique and unprecedented in his oeuvre and in Spain, even in Europe, in his time. Velázquez's *Venus*, which Goya must have seen in the Duchess of Alba's collection, is its only comparable predecessor in the life-like portrayal of the female nude. But where the Velázquez is also a mythological painting, Goya's *Maja* makes no pretence of being anything but a rendering of a naked woman lying on a couch. As a pair of paintings of a single figure in an identical pose the *Majas* are a highly original invention. The theory that the clothed woman was intended as a cover for the naked one is very credible. It is not surprising that the *Majas* attracted the attention of the Inquisition in Madrid in 1814. Even in 1865, when Manet's *Olympia* (such a close relation that it is difficult to believe that the artist had not seen Goya's painting) was exhibited in the Paris Salon, it created a furious scandal.

24. PORTRAIT OF ANDRÉS DEL PERAL. Panel, 95 × 65.7 cm. 1798. London, National Gallery.

According to a modern label on the back of the picture, the sitter was a doctor of law, and financial representative of the Spanish government in Paris at the end of the 18th century. He is known to have been a collector and to have owned a number of paintings by Goya. When the portrait of Peral was exhibited in the Academy of San Fernando in Madrid it was the subject of enthusiastic praise from an anonymous writer in the *Diario de Madrid* (17 August 1798): 'The portrait of don Andrés del Peral executed by the incomparable Goya would by itself be sufficient to recommend to posterity the whole of an Academy, the whole of a nation, the whole of the present age: so great is the correctness of drawing, the taste in colour, the freedom, the understanding of chiaroscuro, in short, so great is the knowledge with which this Professor carries out his work.' It is interesting to find such fulsome appreciation of a painting which in fact defies the rules of 'correctness of drawing'.

25. PORTRAIT OF ANTONIA ZÁRATE. Canvas, 103.5 × 81.9 cm. About 1805. Blessington, Ireland, Sir Alfred Beit, Bt.

The sitter was a leading actress, mother of the playwright Gil y Zárate and one of several members of the theatrical world portrayed by Goya. She was born in 1775 and would have been thirty years old at the time when this portrait was probably painted. She died in 1811. Another bust portrait has been dated earlier by some critics and later by others. But the pose and details of her face and coiffure are so similar – only the dress and headdress are different – that the two portraits cannot be very different in date. The yellow settee appears in other portraits by Goya (for example the portrait of Pérez Estala in the Kunsthalle, Hamburg) and was probably a studio property. Nowhere, however, does it provide a more effective setting than here, as a background to the black-dressed, dark-haired, beautiful actress.

26. PORTRAIT OF VICTOR GUYE. 104.5 × 83.5 cm. 1810. Washington, D.C. The National Gallery of Art.

The sitter was page to Joseph Bonaparte and nephew of General Nicholas Guye, who was also portrayed by Goya in 1810. During the French occupation of Madrid – at the time when he was working on the drawings for the *Desastres de la Guerra* – Goya painted several portraits of Frenchmen and pro-French Spaniards. Little or nothing of his avowed hostility to the French invaders is revealed in these works – least of all in this sympathetic portrayal of a French child.

27. THE COLOSSUS. Canvas, 116 × 105 cm. About 1810–12. Madrid, Prado.

This moving and enigmatic painting, listed in the inventory of Goya's possessions in 1812, certainly relates to the Napoleonic invasion of Spain. In 1812 it was called *El Gigante* (The giant). To-day it is known as the *Colossus* or *Panic*, titles which are more expressive, though its meaning is still problematic. The giant torso, rising out of the clouds behind a scene of men and animals put to flight, has been interpreted alternatively as a symbol of Napoleon and of War. Recently Professor Nigel Glendinning has suggested that Goya's painting may have been inspired by J. B. Arriaza's *Profecía del Pirineo*, a patriotic poem that was in circulation since 1808, in which a Colossus, that is the spirit or guardian of Spain, rises against Napoleon and the French forces and defeats them. A later engraving by Goya, also formerly described (by his grandson) as 'a giant', shows a similar figure seated on a hill beneath a crescent moon, a meditative, passive counterpart to the threatening *Colossus* of the painting.

28. PORTRAIT OF FRANCISCA SABASA GARCÍA. 71 × 58 cm. About 1806–8. Washington, D.C., The National Gallery of Art (Mellon Collection).

The name of this young woman was for many years unknown. She is now identified as Francisca Sabasa García who, according to one account, became the wife of Manuel García de la Prada, Chief Magistrate of Madrid and a patron of Goya. According to another account she married Señor Peñuelas of Toledo. She is also supposed to have been the niece of Evaristo Pérez de Castro, a diplomat, and Goya is said to have been struck by her beauty when he was painting her uncle and asked her to sit to him. This is probably a legend. There is no evidence that Goya ever acted in this way. Moreover, his portrait of Pérez de Castro (Louvre) – if he was this woman's uncle – is almost certainly of an earlier date. Even if Goya did not invite her to pose for him, it is difficult to believe that he did not help to choose the white mantilla and yellow scarf that set off so brilliantly her own colouring.

29. PORTRAIT OF THE DUKE OF WELLINGTON. Panel, 64 × 52 cm. 1812. London, National Gallery.

There are three portraits in oils of Wellington by Goya, one large equestrian portrait (London, Apsley House), this bust and a half-length (Washington, National Gallery), and two drawings. All are related, but the order

of their execution and their precise interrelations are difficult to determine. It has been suggested that the drawings may have been made in preparation for an etching that was never executed. The British Museum drawing, in which the head mostly closely resembles the head in the paintings, may, however, have served as a study for these. An inscription on this drawing says that it was a study for the equestrian portrait and an accompanying note (said to be in the hand either of Goya's grandson or of his friend Carderera), that it was made at Alba de Tormes after the Battle of Arápiles (i.e. Salamanca). The battle was fought on 22 July 1812 and Wellington was at Alba de Tormes on the following day, but it is unlikely that he was able to sit to Goya before he entered Madrid on 12 August. The equestrian portrait, the only one for which documents exist, must have been painted between 12 August and 2 September, when it was to be exhibited in the Academy of San Fernando (*Diario de Madrid*, 1 September). It is of this portrait that Goya writes in a letter: 'Yesterday His Excellency Señor Willington [*sic*] was here. . . . We discussed showing his portrait to the public in the Royal Academy at which he expressed great pleasure. . . . It is a compliment to His Excellency and to the public.' The letter seems to refute the story of Wellington's disapproval and Goya's violent reaction to it.

The National Gallery painting, as well as the half-length portrait cloaked and hatted, were probably painted at the same time as the equestrian composition, when Wellington was still the Earl of Wellington, and Lieutenant-General, before he left Madrid on 1 September. Of the three paintings, the head in the National Gallery version is the most lively and the most likely to have been taken from the life. It is also the only one that represents Wellington in full military costume and the most ceremonial in appearance. Some of the decorations that he wears were received after he left Madrid in 1812 and the alterations that are visible in the painting may have been made in May 1814, when Wellington returned there as Ambassador to Ferdinand VII. The portrait is said to have been presented by the Duke to his sister-in-law, the Marchioness of Wellesley.

30. THE 2ND OF MAY, 1808: THE CHARGE OF THE MAMELUKES. 266×345 cms. 1814. Madrid, Prado.

After the expulsion of the Napoleonic armies in 1814 Goya applied for, and was granted, official financial aid in order 'to perpetuate with the brush the most notable and heroic actions or scenes of our glorious insurrection against the tyrant of Europe'. The two scenes that he recorded (see also Pl. 31) are not victorious battles but acts of anonymous heroism in the face of defeat. Here the people of Madrid armed with knives and rough weapons are seen attacking a group of mounted Egyptian soldiers (Mamelukes) and a cuirassier of the Imperial army. The composition without a focal point or emphasis on any single action creates a vivid impression of actuality, as if Goya had not only witnessed the scene – as he is alleged to have done – but had recorded it on the spot.

31. THE 3RD OF MAY 1808: THE EXECUTION OF THE DEFENDERS OF MADRID. Canvas, 266×345 cm. 1814. Madrid, Prado.

Painted at the same time as the *2nd of May* (Pl. 30). Goya here represents another of the 'most notable and heroic actions . . . of our glorious insurrection against the tyrant of Europe' by a dramatic execution scene. The insurrection of the people of Madrid against the Napoleonic army was savagely punished by arrests and executions continuing throughout the night of the 2nd May and the following morning. There is a legend that Goya witnessed the executions on the hill of Príncipe Pío, on the outskirts of Madrid, from the window of his house and that, enraged by what he had seen, he went to visit the spot immediately afterwards and made sketches of the corpses by the light of a lantern. Whether Goya saw for himself this or any similar scene or knew them by hearsay only, the military executions of civilians is a theme that evidently impressed him deeply. He represented it in several etchings of the *Desastres de la Guerra* and in some small paintings as well as in this monumental picture. Here the drama is enacted against a barren hill beneath a night sky. The light of an enormous lantern on the ground between the victims and their executioners picks out the white shirt of the terrified kneeling figure with outstretched arms. The postures, gestures and expressions of the *madrileños* and the closed impersonal line of the backs of the soldiers facing them with levelled muskets, emphasize the horror of the scene. The dramatic qualities of this composition, with its pity for the execution of anonymous victims and its celebration of their heroism, inspired Manet's *Execution of the Emperor Maximilian*. (See also Pl. 34.)

32. ALLEGORY OF THE CITY OF MADRID. Canvas, 260×195 cm. 1810. Madrid, Ayuntamiento.

At the end of 1809, during the French occupation of Madrid, Goya was chosen as '*el pintor madrileño por excelencia*' to paint a portrait of Joseph Bonaparte for the City Council. In the absence of the French king, Goya composed this picture, described at the time as 'certainly worthy of the purpose for which it was intended', introducing the portrait of Joseph (after an engraving) in the medallion, to which the figure personifying Madrid points. With the changing fortunes of the war this portrait was replaced (by other hands) by the word '*Constitución*', by another portrait of Joseph, again by '*Constitución*' and at the end of the war by a portrait of Ferdinand VII. Eventually in 1843 it received the present inscription *DOS DE MAYO* in reference to the popular rising against the French in Madrid in 1808 (see Pl. 30). The surprisingly conventional allegorical composition is perhaps dictated by the purpose for which it was originally painted. It contrasts strikingly with the realism and fervour of the scenes from the rising which Goya painted four years later (Pls. 30 and 31).

33. PORTRAIT OF FERDINAND VII. Canvas, 207×144 cm. About 1814. Madrid, Prado. Signed (upside down): *Goya*.

After the restoration of Ferdinand VII in 1814, Goya was commissioned to paint several portraits of him for ministries and public buildings. For these he seems to have used the same study of the King's head, possibly the drawing in the Academy of San Fernando, Madrid. The pose, the setting and the costume are varied to suit the occasion. The effect – perhaps intentional – is that of a living head on the body of a dummy. In this ceremonial portrait, the King appears in the uniform of a Captain General with a military camp in the background – a conventional formula, since he had taken part in no military campaign, having spent the war years in France. The broad painting of the costume and decorations and the sketchy treatment of the background direct attention to the head of the King which stands out as a grimly realistic character study.

34. DETAIL OF PLATE 31.

35. A PRISON SCENE. Zinc, 42.9 × 31.7 cm. About 1810–14. Barnard Castle, Bowes Museum.

This prison scene is related in style and character to a number of small paintings of war scenes and other subjects inspired by the Napoleonic invasion. Prisoners – not only prisoners of war – are among the victims of injustice and cruelty that figure in many of Goya's drawings and engravings. A garroted man is the subject of one of his earliest etchings and various other forms of punishment and torture are represented in later graphic works. Three etchings of about 1815 show chained and shackled prisoners very similar to those in the painting. This prison scene, executed with a minimum of colour, is remarkable for the atmosphere of gloom and the effect of anonymous suffering created by the lightly painted, indistinct figures in an enormous cavern-like setting.

36. PORTRAIT OF A LADY WITH A FAN. Canvas, 103 × 83 cm. About 1806–7. Paris, Louvre.

It has been suggested (by Dr. Xavier de Salas) that this handsome, plump young woman is Goya's daughter-in-law, Gumersinda Goicoechea, and that the portrait was painted shortly before or shortly after the birth of his grandson Mariano (see Pl. 37). Though it is difficult to judge the resemblance to Goya's other portraits of Gumersinda – a profile drawing, a miniature in near profile and a full-length portrait of a much slimmer and more elegant figure, with a different coiffure – there is a similarity in the features that makes the identification credible. The portrait was in the collection of Goya's son but when it left his collection the name of the sitter was forgotten.

37. PORTRAIT OF MARIANO GOYA, THE ARTIST'S GRANDSON. Panel, 59 × 47 cm. About 1812–14. Madrid, Duque de Albuquerque.

Signed on the back of the panel: *Goya, a su nieto* (Goya to his grandson).

Goya's only grandson, Mariano, was born on 11 July 1806. There is an earlier full-length portrait of him by Goya aged about four and a head and shoulders of him as a young man in 1827. In the present portrait he appears to be six to eight years old. Seated beside an enormous musical score he is beating time with a roll of paper. This natural gesture, the informal pose and the thoughtful look on the child's face combine to make this one of the most intimate of Goya's portraits and reflects the great affection that he is known to have had for his grandson.

38. A WOMAN READING A LETTER. Canvas, 181 × 122 cm. About 1814–18. Lille, Musée de Beaux-Arts.

Like many other uncommissioned works the subject of this painting has been interpreted in various ways and it has borne several different descriptive titles. The woman reading the letter has been thought to be a portrait. One critic even suggested that she was the Duchess of Alba (who had died many years before the painting was made), and that she is represented with washerwomen in the background to illustrate a theme of Industry and Idleness. It has also been suggested that Goya intended this painting as a pendant to *Time and the Old Women*. The two canvases are the same size, were acquired for the Lille Museum at the same time and have the same provenance. But there seems to be no connection between the subjects of the two paintings and *Time and the Old Women*, which is known to have been in Goya's possession in 1812, is most certainly an earlier work. There is, in fact, little reason to doubt that the woman reading a letter, standing with her companion and dog in front of a group of washerwomen, is a genre subject like the earlier tapestry cartoons and other decorative paintings. But the composition is less contrived and, as in many other works, chiefly the uncommissioned ones, it appears to be based on a scene that the artist had witnessed and recorded on the spot or from memory – a subject for a snapshot. This was one of four paintings by Goya in the collection of King Louis Philippe which had been obtained in Madrid from Goya's son (see also Pl. 39). It was sold at Christie's in 1853 for £21.

39. THE FORGE. Canvas, 191 × 121 cm. About 1819. New York, The Frick Collection.

The group of blacksmiths is based on a brown wash drawing of *Three men digging* (Metropolitan Museum, New York), which belonged to an album dated 1819 by Carderera. Goya has adapted the figures in such a way that the painting, like the drawing, gives the impression of a study from life. The subject is of a kind that he frequently recorded in drawings; there are many similar documentary scenes of men and women of the people in the 1819 series. As a painting the *Forge* is distantly related to *The Injured Mason* (Pl. 4) and similar in character to the small *Water-carrier* and *Knife-Grinder* (Budapest Museum), which were in the artist's possession in 1812. But as a large-scale close-up view of men at work it is unique in Goya's oeuvre. The late sketchy style emphasizes the brutish appearance of all three figures and the vigorous attitudes of the blacksmiths, suggestive of enormous strength. The *Forge* was undoubtedly an uncommissioned painting, which passed into the possession

of Goya's son (See also Pl. 38). It was later in the collection of King Louis Philippe and was sold at Christie's in 1853 for £10.

40. PORTRAIT OF JUAN ANTONIO CUERVO. Canvas, 120×87 cm. 1819. Cleveland, Museum of Art. Signed: *Dn. Juan Anto/Cuervo/Directr de la Rl/Academia de Sn/Fernando/Por su amigo Goya/año 1819.*
The sitter was an architect who was appointed Director of the Royal Academy of San Fernando in August 1815. He wears the uniform of his office and holds dividers, an attribute of his profession. The plan on the table beside him is possibly for the church of Santiago in Madrid on which he had worked in 1811, and which made his reputation. The portrait was probably finished before Goya fell ill at the end of 1819 and is one of his latest official portraits. The inscription indicates that it is at the same time a portrait of a friend.

41. PORTRAIT OF RAMÓN SATUÉ. Canvas, 104 ×81.3 cm. 1823 (?). Amsterdam, Rijksmuseum. Signed: *D. Ramon Satue/Alcalde d Corte/Pr. Goya 1823.*
The sitter has been identified as a nephew of José Duaso y Latre, the clergyman in whose house Goya took shelter in 1823 at the end of the liberal interlude. It has been suggested that the date in the inscription has been altered and that the portrait was painted not later than 1820, the last year in which Satué held office as *Alcalde de Corte* (a City Councillor of Madrid). From the costume, the informal pose and the style of painting it could have been painted either in 1820 or 1823.

42. FANTASTIC VISION (detail). Canvas (whole painting), 123×265 cm. Madrid, Prado.

43. PILGRIMAGE TO SAN ISIDRO (detail). Canvas (whole painting), 140×438 cm. Madrid, Prado.

44. LAUGHING FIGURES. Canvas, 125×66 cm. Madrid, Prado.

45. SATURN DEVOURING ONE OF HIS CHILDREN. Canvas, 146×83 cm. About 1820-1823. Madrid, Prado.
The fourteen 'black' paintings (now in the Prado), so-called because of the dark tones and predominance of black, originally decorated the *Quinta del Sordo*, Goya's house on the outskirts of Madrid. They were painted in oils on the walls of two rooms, on the ground floor and first floor, and transferred to canvas in 1873. Goya acquired the house in September 1819, but probably did not begin the paintings before the following year, after his recovery from serious illness. They must have been finished by 17 September 1823, when he donated the property to his seventeen-year-old grandson, shortly before he went into hiding. Though it is possible to reconstruct the arrangement of the paintings in the two rooms, many of their subjects defy description and the meaning of these sombre, horrific inventions is as difficult to decipher as their appearance is sinister and forbidding. 'The sleep of reason produces monsters', Goya's title to his first design for the frontispiece of the *Caprichos*, would

be even more fitting as a title to this array of nightmare visions, created by the artist in his mid-seventies. Some attempts have been made to interpret individual scenes as history, literature, fable or allegory and to find some theme to fit the whole series. The monstrous inhuman *Saturn*, one of the most striking of all the subjects, has been thought to provide a central idea, either as the triumph of ignorance and darkness or as a symbol of melancholy and old age. There is also a possibility that the *Saturn* decorated the dining room, which would make it a macabre joke. But without documentary evidence – and the earliest record of the paintings, made in 1828, throws no light on their meaning – the key to their mystery is difficult to find. But like the *Proverbios* or *Disparates*, the series of etchings of about the same date, their mystery may have been partly intentional. Their enigmatic, private character certainly contributes to the expressiveness of the compositions and of the manner of painting so that their impact is profoundly disturbing.

46. TÍO PAQUETE. Canvas, 39.1×31.1 cm. About 1820. Lugano, Thyssen Collection.
According to Viñaza (1887) the painting was formerly in the collection of Goya's grandson, Mariano, and before it was relined the canvas was inscribed on the back: *El celebre ciego fijo* ('The famous blind man'). The same writer identifies the sitter as a well-known beggar who used to sit on the steps of the church of San Felipe el Real in Madrid, and was invited to play the guitar and sing in the houses of members of the court. Goya creates a vivid impression of the blind eyes and jovial expression of the old man in a style close to that of the 'black paintings'. At the same time it is remarkably similar to the manner of Velázquez in his portrayal of the facial expressions of court dwarfs.

47. STILL-LIFE: A BUTCHER'S COUNTER. Canvas, 45×62 cm. About 1824. Paris, Louvre. Signed: *Goya.*
A dozen *bodegones* and a painting of birds are recorded in the inventory of Goya's possessions made in 1812, after the death of his wife, and according to his French biographer, Matheron, he painted several still-lifes in the market at Bordeaux during his last years there. The present example is probably one of his late works and is remarkable for its period because of the casual arrangement of the sheep's head and sides of mutton. The signature is painted in red as if to simulate blood.

48. ST. PETER REPENTANT. Canvas, 29×25½ in. About 1823-1825. Washington, D.C., The Phillips Collection. Signed: *Goya.*
The *St. Peter* and a half-length *St. Paul*, which is probably a pendant, are amongst Goya's last devotional subjects. In style they are close to the 'black paintings' and must have been made shortly before Goya left Spain or in Bordeaux. This portrayal of an old man praying, in Goya's late manner, is more expressive of religious emotion than any of his earlier representations of Saints (Cf. the *St. Gregory*, Pl. 5).

Bibliography

L. Matheron, *Goya*, Paris, 1858

Conde de la Viñaza, *Goya: su tiempo, su vida, sus obras*, Madrid, 1887

A. de Beruete y Moret, *Goya, pintor de retratos*, Madrid, 1916

A. de Beruete y Moret, *Goya, composiciones y figuras*, Madrid, 1917

A. L. Mayer, *Francisco de Goya*, English ed., London, 1924

Goya: Colección de cuadros y dibujos precedida de su biografía y de un epistolario, pub. Calleja, Madrid, 1924

V. de Sambricio, *Tapices de Goya*, Madrid, 1946

E. Lafuente Ferrari, *Antecedentes, coincidencias e influencias del arte de Goya*, Madrid, 1947

F. D. Klingender, *Goya in the democratic tradition*, London, 1948; 2nd ed., London, 1968

X. Desparmet Fitz-Gerald, *L'Oeuvre peint de Goya*, Paris, 1950

F. J. Sánchez Cantón, *Vida y obras de Goya*, Madrid, 1951

E. Lafuente Ferrari, *The frescoes in San Antonio de la Florida in Madrid: Historical and critical study*, New York, 1955

P. Gassier, *Goya*, Paris, 1962

Edith F. Helman, *Trasmundo de Goya*, Madrid, 1963

F. J. Sánchez Cantón, *Goya and the Black Paintings*, with an Appendix by X. de Salas, London, 1964

F. J. Sánchez Cantón, *Museo del Prado: Los dibujos de Goya*, Madrid, 1954

J. López-Rey, *A cycle of Goya's drawings*, London, 1956

J. López-Rey, *Goya's Caprichos*, Princeton, 1953

T. Harris, *Goya: Engravings and lithographs*, Oxford, 1964

List of collections